Amana Style

An Enduring Jewel in the Heart of Iowa

Amana was settled as a place of refuge in the Iowa prairie in the 1850s. The artisans and craftsmen of the past help tell the story. Today, even though the sandstone on the houses and barns has weathered and communal kitchens converted into family-style restaurants, the artisans and craftsmen continue to extend the story for future generations.

—Marjorie K. Albers

Amana Style

Furniture, Arts, Crafts, Architecture, & Gardens

Persian Yellow Rose
lithograph by Joseph Prestele

by
Marjorie K. Albers and Peter Hoehnle

Dedication and Acknowledgments

Dedicated to the people of Iowa's seven Amana villages:
Amana, East, Middle, High, West, South, and Homestead

Acknowledgments

Special thanks to Lanny Haldy, Executive Director of the Amana Heritage Society, and Mary Bennett, Special Collections Coordinator of the State Historical Society of Iowa. In addition to those who are mentioned in the book, we thank William Ackerman, Marvin Bendorf, Barbara Hoehnle, Elly Schrodt, Reynold Moesser, and Allyn Neubauer. This book is a partial revision of *The Amana People and Their Furniture* by Marjorie K. Albers, ©1990 Iowa State University Press.

Front cover: Gordon and DeAnna Kellenberger have a traditional, weathered, unpainted home in High Amana where they enjoy their art studios.

Back cover: The South Amana brick home of Larry and Wilma Rettig has Virginia creeper, native to the woods of Amana, and a mix of vines, including a rare clematis called Summer Snow that blooms spring to fall. Plantings include petunias in a wine barrel, red salvia, and orange double day lilies.

Color and current black-and-white photography by Joan Liffring-Zug Bourret and John Johnson.

Photographs from the collections of Peter Hoehnle, Marjorie K. Albers, including furniture, photographed by Peter A. Krumhardt, the State Historical Society of Iowa collections.

Prestele lithographs and paintings of fruits and flowers, and historic photographs courtesy of the Amana Heritage Society.

Editors: Dwayne and Joan Liffring-Zug Bourret, Melinda Bradnan, Miriam Canter, Dorothy Crum, Maureen Patterson, and Connie Schnoebelen

Graphics: Molly Cook, M.A. Cook Design, and Kathy Timmerman
Printing: Ernie Visser, Pella Printing, Pella, Iowa

Contents

Preface

This book begins with a brief history of the development of the Community of True Inspiration from the time of its inception to the present day. Later chapters explore the styles and development of the various Amana arts, crafts, furniture, architecture, and gardens created by the Amana people.

Professionals who study the history of design frequently use the chair as a point of departure. The characteristics of a chair crafted within a particular period provide considerable knowledge about the background of the people who created it, their culture, and often insight into the design influence on pieces crafted and used today.

When having lunch at the Colony Inn Restaurant in the village of Amana, the diner may be seated on a "Dutch" chair, a replica of a side chair that was used in the inns of Europe in the sixteenth century. This chair tells a story. It has the characteristics of a furniture piece that was made at a time when life was often described as "boisterous," and furniture, of necessity, had to be simple in line, sturdy, easily constructed, and made of readily available material, with no carving, no turning, and no intricate inlay. The chair was made to meet the needs of an era and its people.

The image of the chair can be easily correlated to the design of numerous other arts and crafts that have been handed down through the generations as well, some more pronounced than others. I have attempted to describe how the early beginnings and basic needs of the Amana settlers helped to successfully shape the use of at-hand materials, manual skills, knowledge, and imagination into the productive crafting of furniture, carpet weaving, Easter egg dyeing, broom and basket making, quilting of comforters, and much more. The dedication and devotion of the various artisans are related throughout.

—Marjorie K. Albers

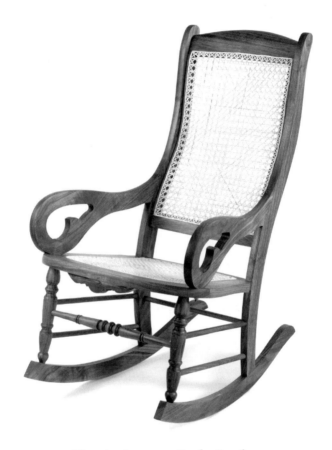

Classic Amana Style Rocker

Every Amana living room had a rocker designed in this basic traditional style. Hardwoods of walnut, oak, and cherry are used for these rockers. Note the caned back and seat.

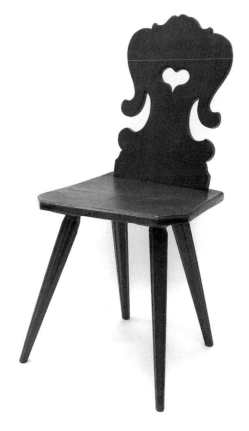

The Dutch Chair

This chair, popular in Europe, came with the Schnaebele family to America in the 1840s, and later to the Amanas. Copies of it were made for The Colony Inn, the first restaurant to open in the Amanas after The Great Change in 1932.

The Seven Amana Villages in Iowa

Amana History

Today's Amana community has its roots in the late seventeenth century Pietist movement, whose adherents sought a closer and more meaningful relationship with God through Bible study and simple religious gatherings. They placed particular emphasis on a personal conversion experience, and criticized the formality and ceremony found in the Lutheran state church of the day. While most Pietists sought to reform the church from within, others, including the Amana forebears, believed that this task was impossible and became Separatists.

In 1714 a group of Separatists, under the leadership of Eberhard Ludwig Gruber and Johann Friedrich Rock, and known as "the Community of True Inspiration," coalesced around the idea that God could prompt individuals to proclaim His will on earth. Called "Inspirationists," members believed that specially endowed and pious individuals, known as *Werkzeuge,* or instruments, would become inspired and deliver messages inspired directly by God. This group, like many other Pietist organizations, believed in baptism by the Holy Spirit and so did not perform a water baptism ceremony. They were also strict pacifists. Throughout the eighteenth century, group members were persecuted for their beliefs by church and state officials.

After the death of J.F. Rock in 1749, the group was left without a *Werkzeug* until a journeyman tailor, Michael Krausert, began delivering testimonies in 1817. Krausert was soon joined by Barbara Heinemann (1795–1883), an uneducated serving maid from Alsace, and together they led a revival of the movement. Following disagreements, Krausert left the sect. Heinemann, tired of the burden of leadership, decided to marry and abandon leadership, which was assumed by Christian Metz (1794–1867), a carpenter and fellow *Werkzeug.* As the political and economic situation in central Europe worsened, Metz gathered the scattered congregations of Inspirationists together in the liberal province of Hesse.

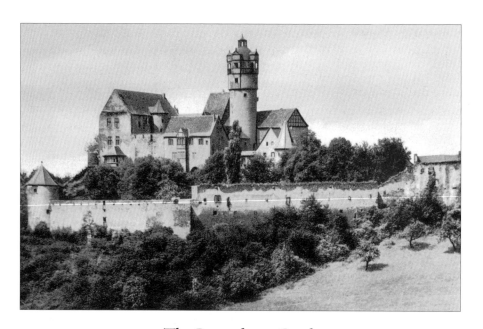

The Ronneburg Castle
This castle near Büedingen, Hesse, Germany, was one of several sites where shelter was granted to members of the Community of True Inspiration.

Metz leased several castles and cloisters in which the Inspirationists lived communally in an isolated environment where his followers could escape persecution, unwanted military service and wars, and frequent outbreaks of disease, plus have the freedom they wanted. The melding of people from various cultures and nationalities in these communities strengthened their religious beliefs and helped unify their differing customs, tastes, and way of life, including their artistic expression.

The first of these estates was the five-hundred-year-old Ronneburg Castle, located near Büedingen. During the 1820s, as persecution forced many Inspirationists to flee their home provinces, they leased a succession of additional estates. The first of these properties, leased in 1826, was the Marienborn estate, followed in 1828 by Herrn Haag, a collection of buildings originally constructed to house a Moravian religious community; Engelthal, a former Catholic convent, in 1835; and Arnsburg, a former monastery that the Inspirationists renamed Armenburg (castle of the poor) in 1832. All the sites except Armenburg were near one another; most could be viewed from Ronneburg.

In 1842, Metz delivered a testimony directing the Inspirationists to look for a new home in America, and the community sent a committee of four westward. With the help of a German land agent, they found suitable land near Buffalo in upstate New York, where a Seneca Indian Reservation was being vacated. Metz continued to deliver more testimonies to support the acquisition of a new homeland, which became known as "Ebenezer," a Biblical term meaning "hitherto the Lord has helped us."

The Inspirationists drafted a constitution that established a communal way of life. The economic communal system from Europe was further developed through common land ownership, business enterprises, and communal kitchens. As soon as word reached Germany, more than eight hundred Inspirationists migrated to the new settlement. As the population increased, the community organized four villages—Middle, Upper, Lower, and New Ebenezer—in New York and two additional ones, Canada Ebenezer and Kenneburg, across the border in Canada.

The encroaching urbanization of Buffalo posed problems. A dam on Buffalo Creek backed water up into Ebenezer, resulting in less water power for the mills. It was possible that soon a railroad would be built through the middle of the land occupied by these new immigrants. There were no adjacent agricultural acres available for future expansion. As Metz wrote in a letter to a German associate, "We love . . . seclusion and privacy . . . and [Buffalo] is not a good influence on our young people." Finally, negative feelings about the Inspirationists, partially motivated by anti-immigrant sentiment, had grown in the surrounding towns.

The Move to Iowa

In August 1854, Christian Metz delivered another testimony to move westward. A search committee traveled to Kansas but purchased no land. Metz heard promising news about the availability of good land in Iowa, and within two months sent a committee of two to explore the area. Both men were greatly impressed. In the spring of the next year, 1855, a contingent of four traveled to Iowa and all agreed that the beautiful valley of the Iowa River was suitable. The area included natural resources such as rolling prairie, the Iowa River, several small waterways for power, ice, and fishing, and stone and timberlands of walnut, oak, hickory, and maple. Of utmost importance was the fact that the land was affordable and had the desirable isolation.

A New Community in Iowa

The physical move to Iowa was not easy. The first group of thirty-three hand-picked settlers left Ebenezer in July 1855. It was made up of men representing a cross-section of the various trades along with a few women. The Inspirationists came by train to the Iowa-Illinois border. Then they walked five, ten, and sometimes fifteen miles a day alongside oxen-pulled wagons to reach Amana. Wagon space was largely devoted to transporting basic furnishings, supplies, and equipment necessary to establish the new community. It was helpful to have at least one person who spoke English. The last group to leave New York departed in December 1864, three years after the start of the Civil War.

The first years were especially difficult. Building materials and manpower were limited. The winter of 1856 was harsh with considerable snow and extremely cold temperatures. Heavy spring rains caused severe flooding of the waterways and lowlands in 1861. There were no bridges across the Iowa River or the other streams that cut their way through the woodland and grasslands. The distance between the villages had to be traversed by foot or horse and wagon. Oxen were used to till the soil. The lack of modern infrastructure gave these religious people the isolation they so avidly sought. Modern highways, the automobile, telephones, books, and the radio later brought the outside world into their midst.

The new settlement was named "Amana," a Biblical term (Song of Solomon 4:8) signifying "remain true." Within only nine years the Society had moved from New York and established six communities on the Iowa prairie and purchased a seventh, Homestead, because of its needed rail connection.

The seven small German villages of Amana, Middle Amana, East Amana, South Amana, West Amana, High Amana, and Homestead—were surrounded by twenty-six thousand acres of rich Iowa soil and timberland. Community members shared freely in the work and rewards. Their homes, furniture, and other material possessions, as well as their food, would be created by their own skilled hands and ingenuity. Simplicity and austerity were ever present and dominated the scene.

The Ambiance of the Iowa Prairie

The prairie was not totally untouched land and wilderness; it was populated by a few tribes of Meskwaki Indians and an occasional settler and family. The presence of Native Americans of an earlier day became evident when the Inspirationists and nearby settlers began turning the virgin soil with the blades of their plows. Periodically, artifacts, from arrowheads and spear points to ax heads and game balls, would surface on the tops of the freshly cultivated fields.

Wild animals, such as coyotes and foxes, were hidden by the grasses that reportedly grew as tall as a horse. The streams and a river flowed with clear, sparkling water and were inhabited by fish, frogs, and muskrats. Occasionally a family of beavers could be seen building a barricade across a waterway. On a quiet and hot summer afternoon, there would likely be an endless clear blue sky dotted with occasional round, white, cumulus, cauliflower-shaped clouds and plenty of midwestern sunshine.

The landscape of winter was vastly different, much like a Currier and Ives Christmas print. The long months of frosty and frigid days were often cold enough to give these former middle Europeans rosy cheeks. The ground was frozen a foot or two beneath the top layers of snow. Many little prairie seeds lay buried deeply under the surface, only to make an early appearance a few months later.

Iowa City, the first capital (1846) of the state of Iowa, was twenty miles east of Amana. To the west was Marengo, a small town with a population of 525 inhabitants that was connected to Amana by railroad in 1860.

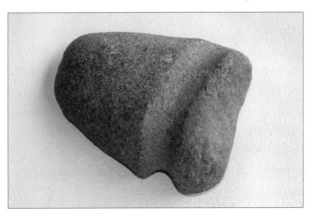

Native American ax head found in the Amanas

The Establishment of Villages

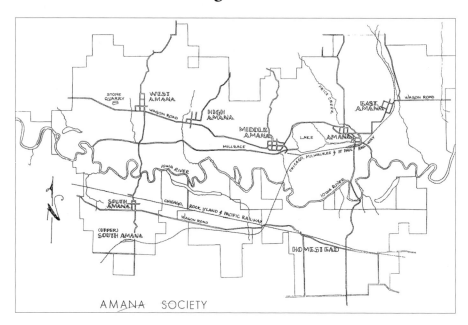

1880 map of the Amana Society

Such were the environs of the new homeland of the Inspirationists. The proximity of building materials, such as sandstone, clay, and timber, and natural waterways had been primary factors in determining the location of the seven villages. Sandstone could be quarried and used for the foundations of houses, churches, mills, factories, stores, shops, barns, and outbuildings such as wash houses. Entire buildings were constructed of the yellow and brown stone, with walls as much as eighteen inches thick. In the 1850s the Society built brickyards to produce molded clay bricks for construction. The timbered hills of oak, cherry, maple, and walnut trees provided wood for constructing other homes and outbuildings, as well as for cord wood for fuel, furniture, and some equipment. Hickory trees, however, were reserved for the village smokehouses for smoking freshly-butchered meat. The waterways met human and animal needs and served as a power source for mill operation.

The villages housed the people, homes, businesses, and craft shops with the farmland, woodland, and pastures in between. The time and costs

usually incurred in obtaining and transporting building materials were minimized by locating the villages approximately two miles apart.

The placement of the Amana villages also served to enforce discipline among the young people. Courtship was not encouraged, as the Inspirationists regarded the celibate life as more pleasing to God. Still, marriage was allowed within the community, although courting was not always easy. A trip of a mile or two by foot or by horse and wagon, would hopefully reduce the frequency of a young man's trips to another village to see a young lady who caught his eye. He was made well-aware that he would have to return early in the evening as he was expected to be up "at the crack of dawn" the following morning to plow the corn or mow some hay, endure a full day of hard labor, and then attend nightly church service. At that time, the rule was that a young man had to be twenty-four before he could marry.

The Amana Village Plan

Each village was planned and built so as to be largely self-sufficient, but varied in size. The villages tended to be organized in blocks with one exception, Homestead, with a single street. The barns and sheds for farm animals were located at one end, the factories and shops at the opposite end, with houses and churches more centrally located. Along the hard-packed dirt roadways and paths to and from the businesses and homes were wooden sidewalks, board fences, or rows of currant bushes. These separated the houses and lamps atop tall wooden posts to light the way home from church if there was no moonlight.

Each community had its own church, school, general store, bakery, communal kitchens, wine cellars, sawmill, orchards, and dairy, as well as a variety of tradesmen. Small businesses and craft shops were sometimes located in the homes while larger ones occupied their own buildings. The bakeries provided fresh hard-crusted European-style loaves of bread to the communal kitchens daily, the butcher fresh meat, and so on. Initially there were two flour and grist mills, one in Main Amana and the second in West Amana. Several of the villages had drying houses for preserving vegetables such as beans, spinach, kale, and for fruit such as apples and pears. The villages of Main and Middle Amana both had woolen mills. A calico print factory was located in Main Amana.

The Houses

The basic houses of brick, stone, or wood were rectangular in shape and one-and-a-half or two stories tall. The basic elements of the homes, such as the symmetrical placement of windows and the modified return gables, reflected the influence of American building styles such as Greek Revival and Federal. The Inspirationists were quick to adapt American styles, but the actual building construction, with heavy timber frames and stone, reflected their European roots.

The exteriors of the frame houses weathered well and were left unpainted because the Inspirationists felt that with their ample supply of wood it was more economical to reside than to repaint. The thick outside walls were filled with nogging: broken brickyard bricks, mud bricks, and straw that served as an insulating material. Paneled doors were centered on the front facade with a small covered stoop. On both sides were symmetrical double-hung small-pane windows on each level. The top half of the fenestration was composed of nine small panes while the lower half had six panes. The full windows were often referred to as "nine over six." There were no shutters for closing when the spring storms rolled across the prairie. Rectangular brick chimneys protruded from the roof or extended from ground level to high beyond the roof at one end or the other. Adjacent to the house foundations were elevated garden areas two feet high and two feet wide. *Rabetten,* held in place by wide planks and filled with rich soil, served as mini-gardens for growing additional vegetables and flowers, and grapes for wine. Almost every building, house, and workshop had tall trellises at the back of these planters that extended high on the side walls of the buildings. In summer the large green grape leaves softened the otherwise rigid profiles of the buildings, while helping to cool their interiors. The *Rabetten* also helped insulate the interior wall space from cold during the winter months. Credit for the idea and style of construction of the *Rabetten* is given to Amana artist and horticulturist Joseph Prestele.

Occasionally a large elm or maple tree was nestled close to a house, providing not only summer shade, but also a home for a family of sparrows or catbirds. Cherry and apple trees in the front yard produced fruit. The back yard was the traditional spot for a vegetable garden, and in one corner, there would likely be a tall pole topped with a martin house.

The Village of Amana

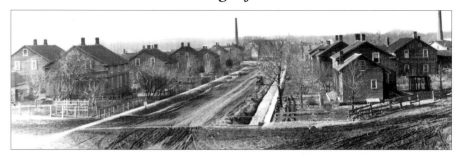

The smokestacks at the woolen mill and calico print factories. Only the woolen mill smokestack remains today. Distinctive Amana features such as wooden fences, grape trellises, and unpainted wood siding are evident.

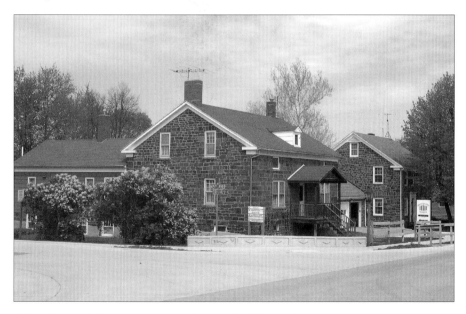

Members of the community began building Amana in 1855. The sandstone home of religious leader Christian Metz is at the left in this view of main street buildings in 2005. The remaining five villages were built in this order: West, 1856; South and High, 1857; East, 1860; and Middle, 1862. The village of Homestead was purchased in 1861 for access to the railroad. The seven Amana villages were each hour apart by ox cart.

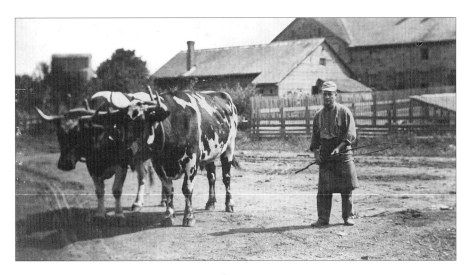

Oxen

Oxen were used to haul heavy loads and to pull the large plows used to break prairie sod. Horses replaced oxen and in turn were replaced by tractors by the 1930s.

The Amana Millrace

The seven-mile millrace was dug from the Iowa River to the villages to supply water power for the woolen and flour mills in Middle and Amana. The village of Amana is in the background.

Typically, older family members occupied a first-floor apartment consisting of a 15 x 15 foot living room and same-sized bedroom, while the younger families occupied similar space on the second floor. Each village had communal kitchens, serving twenty to forty residents, eliminating the need for kitchens and dining rooms in the homes. The interiors had wide, white pine plank flooring, with plastered walls and ceilings whitewashed in "colony blue" calcimine; all interior doors were painted gray. There was usually a wood-burning "Wild Rose" heating stove of cast iron for warmth on the cold days of winter.

As people moved into the houses, they slowly added furniture, piece by piece. The cabinetmakers spent long hours making the basic chairs, wardrobes, chests of drawers, tables, and beds to supply the needs. There were times, however, when large numbers of new believers arrived in groups, requiring a sizable quantity of new furniture to accommodate them. To help fulfill the need, the Society purchased some from the outside. Home accessories—items designated today as arts and crafts—were handmade as time, religion, and resources permitted.

Amana's Great Change and Beyond

Communal life in Amana continued until 1932 when, after a year-long planning process, the members of the Amana Society voted to abandon the communal system and form a joint stock corporation. This corporation was to oversee the economic aspects of the old Society while a separate organization, the Amana Church Society, was formed to direct spiritual affairs. Adult members received shares of stock entitling them to free medical and burial benefits from the corporation. The new corporation closed many of the craft shops that proved unprofitable under the new system while combining others, such as the furniture shops and bakeries, into larger and more efficient operations.

The Amana Society, Inc. continues today, its approximately eight hundred stockholders drawn heavily from communal-era residents and their descendents. The Society continues to manage the twenty-six thousand acres of Amana farmland, the largest private farm in the state of Iowa, as well as a diverse collection of nearly twenty other businesses, including the Amana Woolen Mill, Amana Meat Shop, Amana Furniture Shop, and Amana General Store. Since the 1960s, the Amana Colonies have

become one of the Midwest's premier tourist attractions, playing host to well over a million visitors a year.

The Amana Church Society continues to preserve the religious beliefs and observances of the Community of True Inspiration. Since 1961, the Church has held services in English, as well as German, but members still gather in the same plain meetinghouses as their religious forebears, sing the same hymns, and read from the testimonies of the *Werkzeuge*.

The following chapters will detail the role of arts and crafts in communal Amana, and how a large number of them have survived and, in many cases, thrived in Amana since The Great Change of 1932.

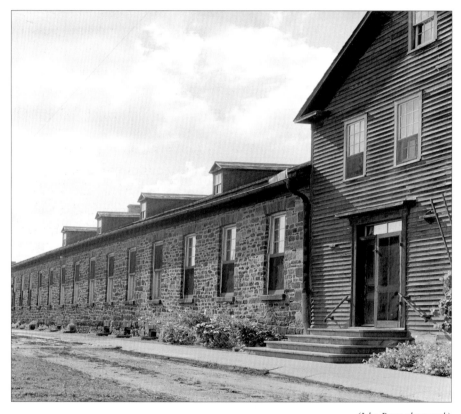

(John Barry photograph)

Meetinghouse, Amana 1937

Personal Reflections

From the Perspective of My Family
By Marjorie K. Albers

Amana has played an important role in my family background. My ancestors were among the immigrants who settled in one of the villages. They came from Medow bei Goldberg in what was then Prussia, now the German province of Mecklenburg-Vorpommern. Rigid religious and governmental restrictions, cholera, frequent wars, and required military service were all factors in their decision to move. Work and worship were the mainstay of their daily lives. Medow and nearby Goldberg were small villages surrounded by seemingly endless hectares of farmland and forest land. Each of the two villages had well-appointed, large churches with clergy to administer hope and guidance.

The lure of a faraway place where the family would be able to achieve the promise of religious, governmental, and economic freedom had appeal. Word of the religious work and goals of Christian Metz, the *Werkzeug* and inspired leader of the Community of True Inspiration, had somehow drifted into their community, perhaps through travelers and traders. The new Community of True Inspiration in America sounded ideal—a community of people with similar religious goals, as well as similar ethnic and cultural backgrounds, to serve as a bond. Since my family members could speak only German at the time, the advantage of a common language would also be helpful.

No one in the family had met Christian Metz, but most had heard of him. Inquiries were made through correspondence. Words of hope, encouragement, and inspired guidance came back. The decision to move was made.

Family members who made the trip to America in 1867 were my great-grandfather, Johann Possehl, 59, and his wife, Maria, 57; their son (my grandfather), Heinrich Possehl, 21; a second son, Karl, 16; daughter Sophia Possehl Dahnke, 25, her husband, Johann, 28, and their two children, 2 years and 6 months.

It took considerable courage to leave their homeland and friends, to dispose of the little property they possessed, and to face the possibility of a long and rough ocean voyage. Like so many immigrants they undoubtedly had heard the remarkable stories of others who had made the trying ocean voyages to America: frequent storms, icebergs, shortages of food, bad odors on ship, and crowded conditions.

The New Possehl Home in High Amana, Iowa

The inquiries made of Metz and his response played a major role in my family's decision to immigrate to Amana. Unfortunately, Metz passed away before my ancestors arrived in Iowa. It must have been of great concern for the family to suddenly find themselves among strangers in a foreign land without their promising religious leader to provide guidance. However, the community's old-world charm, people of similar ethnic backgrounds, and concerns about religious freedom made them happy that they made the move.

The elders assigned them a typically large house in *Amana vor der Höhe*, a village known today as High Amana. My grandfather remembered the village of 1867 as having 130 residents living in fourteen houses of frame or sandstone from a nearby quarry. Originally the plan was to build the village on a hill, but rain and mud slides soon caused the village to be located at the base.

The Elders Give Work Assignments

An early work assignment the elders gave to my grandfather was to report to the "timber boss," who told him he would be cutting walnut, maple, and oak trees for new buildings, furniture, fence posts, and firewood. One of the first directives was that trees were not to be cut until they had reached a certain level of maturity. The wood cut for furniture was delivered to barns for drying. Later, he and his co-workers dropped off the cut lengths for fuel in front of homes and shops, where school boys transferred the logs to the wood houses in back.

My grandfather told his children many, many times about the long, frigid Iowa winter work days, extending from 6:00 in the morning until 6:00 in the evening, and how he ate frozen molasses sandwiches prepared

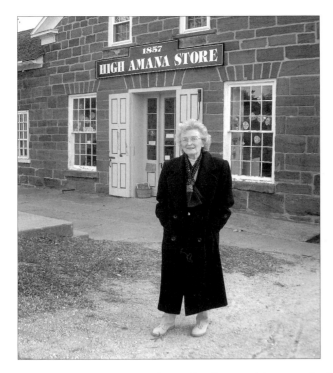

Marjorie Albers stands in front of the entrance to the High Amana Store in the village where her German ancestors first settled in the colonies. Today the store is operated by the Amana Heritage Society.

in the community kitchens for his midday meal while out cutting trees. Women delivered coffee to the men mid-morning and mid-afternoon when the weather was cold, and occasionally a little wine to help warm body and soul.

Another demanding winter duty was cutting ice on the Iowa River, and then moving the chunks on oxen-pulled sledges over snow-packed roadways to the village ice houses, where the large cold blocks were buried in sawdust until needed the next July and August.

The other men of our family were assigned farm work. Seasonal field work such as planting or harvesting crops required the help of most of the Society's adult men and women. The Possehl women primarily worked as cooks in the communal kitchens.

My grandfather married a Pennsylvania German woman, and they had a family of seven children. During their years in High Amana, they, like other Amana families, rarely traveled to another village. Any travel outside their immediate community involved walking the distance or getting a team of horses and a spring wagon from the farm department and outfitting it with two or three seats.

Wash houses were in separate buildings from the apartments of the villagers. This one is near the High Amana Meetinghouse.

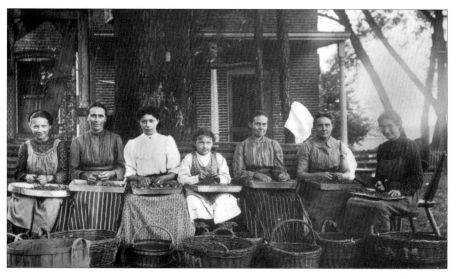

Communal kitchen workers sorting vegetables. The women worked in village community kitchens and gardens. Others cared for the little children in the Kinderschule.

John Barry photographed women gardening in the Amanas and the stacked wood. The people used wood to heat buildings and wood-fired cookstoves in communal kitchens.

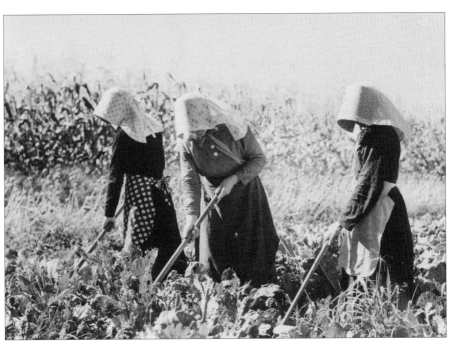

The High Amana Meetinghouse

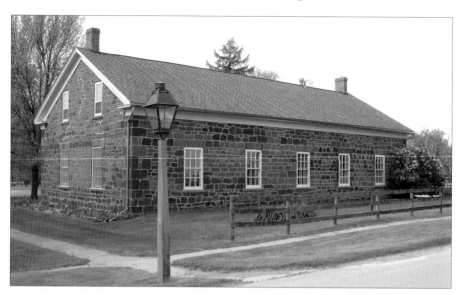

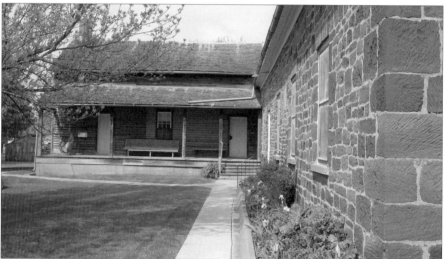

*In use until 1972, the High Amana Meetinghouse building, above,
is largely unchanged since it was built in 1858. The view below is of
the back entrance to the meetinghouse, looking toward the former
village* Kinderschule *for young children. Covered porches are a common
architectural feature in the Amanas. Since 1978, both buildings are
used for exhibitions and workspace by the Amana Arts Guild.*

Another Move

Although my ancestors were comfortable with their lives in High Amana, attended church regularly, and were apparently well accepted, they chose to leave the Society in 1871, as did others throughout the years. Within a few short years of leaving, each male of the family purchased a farm a short distance from that of the others and immediately west of the Amana land. They knew enough about farming to select prime Iowa agricultural land.

After moving to their own farms, they continued to maintain close relationships with the Amana people. When necessary they would travel the seemingly long ten miles from their farms to West Amana to take grain to the grist and flour mill, and then spend the day in High Amana buying supplies and enjoying a little German *Gemuchlichkeit* with their friends and former neighbors.

They continued to live relatively austere lives. While they didn't continue to be members of the Community of True Inspiration in the Amanas, my relatives became members of the Lutheran church as they had in Germany.

My Aunt Returns to Amana

While in her teens, the eldest daughter, my aunt Nora, felt the need to work outside the home. Her familiarity with the Amana Society led her there. She worked at the hotel in Upper South, which was actually a part of the village of South Amana but built a short distance away along the Chicago, Milwaukee, and St. Paul Railroad. The Society erected the hotel in 1884 to accommodate traveling sales people, picnickers, excursionists, and curiosity seekers. Periodically, hungry hobos appeared at the doorway and were always given a meal. Some worked for the Society for a time as day laborers; others were encouraged to move on.

One day, while my mother and I were visiting at the hotel, my aunt asked me if I would like to see a guest room. The three of us walked up a long flight of wooden steps to the second floor and entered one of the unoccupied sleeping rooms. It was light and airy, had blue-painted walls and the traditional gray doors and trim, strips of woven rag carpeting on the floor, a narrow bed, and a couple straight chairs. There was a small square table beside the head of the bed that was covered with a white,

crocheted doily, a kerosene lamp with shades attached to the chimney, and a light-colored flower container holding three yellow marigolds, all very plain and pleasant.

My aunt gestured for me to come closer to the foot of the bed, and she turned back the corner of the bedding and showed me knotted squares of rope attached to the bed frame by means of wooden pegs. Three rectangular sections of a hog-hair-filled mattress lay across the width of the narrow bed on top of the rope surface. She suggested that I squeeze the mattress. It was very firm and hard. The surprise of the rope mattress made a lasting impression on me because I only had known of coil mattresses that were soft with a little springiness and had never thought of the possibility of rope supporting a mattress.

My aunt spoke of the hotel guests on occasion. She was particularly fond of one family of three, a mother, father, and daughter from Cedar Rapids who stayed several weeks each summer. The father, Charles Hickock, had been reared in Vermont and had moved his family to Cedar Rapids so he could teach at Coe College. He missed his native home, where he had been surrounded by heavily forested land, rolling hills, and occasional streams and creeks, but he felt comfortable in the Amanas. He enjoyed visiting there and liked the people and their way of life. After many years of annual summer vacations in the Amanas, the family developed many long-lasting friendships.

Visits to Amana homes were also memorable for me. One Sunday, after the communal system had been replaced by a modified capitalistic system in 1932, some friends invited my family to dinner. They were living in an upstairs apartment that had been modified to include a kitchen and dining room. The furnishings were interesting and so different from ours at home in nearby Marengo. I was given a black spindle-back side chair that had a narrow yellow line painted on the seat parallel to the edge. It was unlike any chair I had ever seen before. I felt that I had a "seat of honor" while eating some of the most delectable apple fritters I had ever known. The rooms had the typical Amana woven striped rag carpets and blue walls. I liked being there.

Numerous other visits to the Amanas throughout the years that followed gave me an opportunity to observe the furnishings and gradually

learn about the high quality of hand craftsmanship that has traditionally been an earmark of all the arts and crafts in these seven villages.

Early Influences Played a Role

Exposure to rope mattresses, woven rag carpets, a black spindle-back chair, and numerous other furnishings and artifacts elsewhere sparked a special interest for me in interior furnishings. Later, after earning a bachelor of arts degree at Iowa State University and a master of arts degree at the University of Iowa, I joined the faculty of the University of Nebraska-Lincoln and taught courses on European and American historic furnishings. My previous publications include professional articles and the book *The Amana People and Their Furniture* (Iowa State University Press, Ames, Iowa, 1990).

In addition to extensive experience as a practicing designer, I served as a color and design consultant in Saudi Arabia during the years my husband, Henry Albers, was an academic dean and governmental advisor there. He, a German-born American, was also very helpful to me in preparing this book.

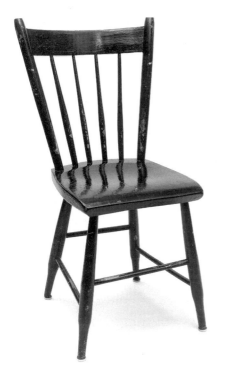

Painted Pine Side Chair
This is the kind of chair Marjorie K. Albers sat in to eat apple fritters during her childhood when her family visited the Amanas.

It is one of the originals used in a former colony hotel and later used in Zuber's Restaurant in Homestead.

Remembering Our Heritage

By Peter Hoehnle

In an age when families move from city to city and town to town, it is less common for an individual to be firmly rooted to a single community than it was a generation or two ago. For many of us in Amana, however, this is not the case. Every one of my forebears for five generations has lived in the Amanas, and in some cases, my family association extends back for ten generations. In my background there are church elders, mapmakers, printers, schoolteachers, a cooper, cobblers, weavers, merchants, kitchen workers, farmers, locksmiths, salesmen, depot agents, and gardeners.

I became a historian because I had little choice in the matter, surrounded as I was by the shelves, files, and albums of community history saved by my forebears, hearing stories told by elderly friends and neighbors, participating in community activities, and learning traditional crafts. I worship in the same meetinghouse as my ancestors and sing some of the same hymns that have been sung since the early 1720s. I've always felt connected to my heritage.

In my willingness to preserve that heritage, however, I, as co-author, have breached etiquette. In Amana there has always been a strong emphasis on anonymity. Very few pieces of furniture or craft work were signed; members were encouraged not to boast of their accomplishments but, instead, were taught to blend their talents and abilities with those of their spiritual brethren and sisters for the uplift and support of the entire community. These German artisans, scholars, and farmers wanted to be left alone to practice their religious faith and lead lives of quiet faith in practice. They were not anxious to convert others to their way of thinking or living, nor did they see themselves, or the products of their hands and minds, as particularly noteworthy.

As a modern descendant, I want their accomplishments to be remembered. The Amana aesthetic, as it applies not only to craftsmanship but also to a spiritual and cultural world view, should be shared with the rest of the world. I hope that this product of our combined pens will help to preserve old Amana for the future. In an age of uprootedness, let us take the time to see the fruit of one tree, tended by faith and love for over a century-and-a-half in the fertile fields of Iowa.

Peter Hoehnle is shown at the 1868 Archives building in Middle Amana, where community records are stored.

In 2003 Peter Hoehnle earned a PhD in agricultural history and rural studies from Iowa State University. He has written numerous articles on communal, agricultural, and Iowa history. He authored The Amana People: The History of a Religious Community *(Penfield Books, Iowa City, Iowa, 2003), and received the Throne Aldrich Award for an article published in the* Annals of Iowa, *a publication of the State Historical Society of Iowa. He is an elder in the Community of True Inspiration.*

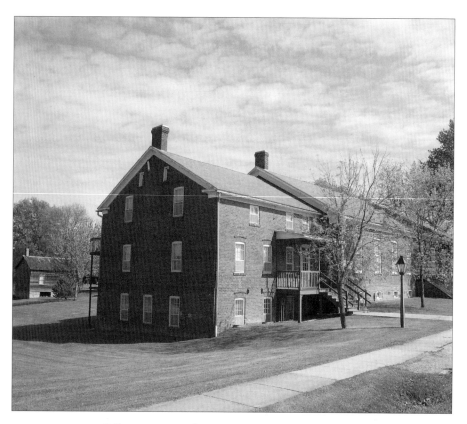

The Meetinghouse in Middle Amana

This 1864 brick meetinghouse is still used for Wednesday evening services and Sunday worship by the Amana Church Society, one service still partially in German, one in English. Men and women use separate entrances and sit on separate sides. The section on the left is the women's entrance and also originally contained apartments.

The small wooden building behind the meetinghouse was the Middle Amana *Kinderschule* (daycare), where children between the ages of 3 and 5 were cared for while their mothers worked in the communal kitchens. The *Kinderschule* was restored in 1979 as a memorial to Phyllis Schuerer Burgher, an early advocate of historic preservation in the Amanas. Six of the Amana villages are under the jurisdiction of the Amana Colonies Land Use District, which sets criteria for the renovation and preservation of historic buildings.

The Colorful Amanas

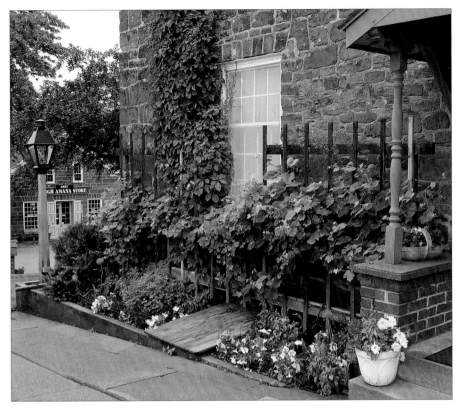

Sandstone Buildings in High Amana

Overlooking the historic High Amana Store built partially of sandstone, the home of Carroll and Janet Zuber was once a communal kitchen serving the villagers in High Amana. The sandstone wall has the traditional grape trellis with vines planted in a raised bed, called a *Rabatte,* a common architectural detail of houses and buildings in the colonies.

These beds also provided room for traditional flowers such as coralbells, bleeding hearts, geraniums, and petunias. Sandstone quarries in Amana, West, Middle, and High Amana supplied building materials for stores and homes. The green tin pole lamp was crafted by William Metz, tinsmith, who revived this craft in the Amanas.

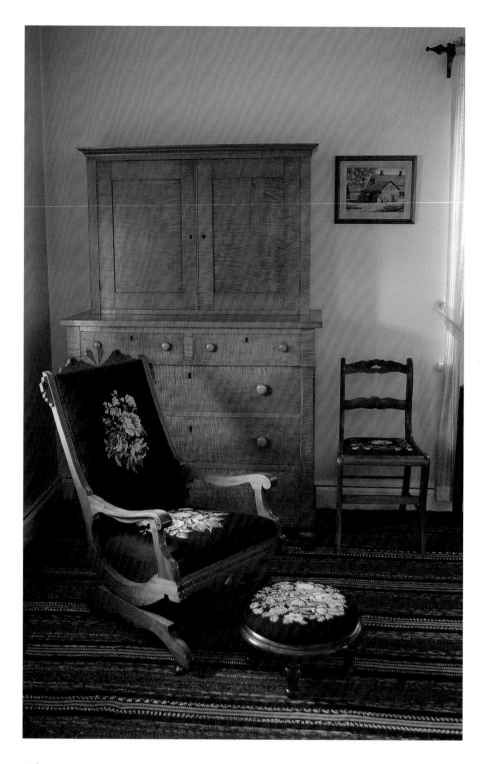

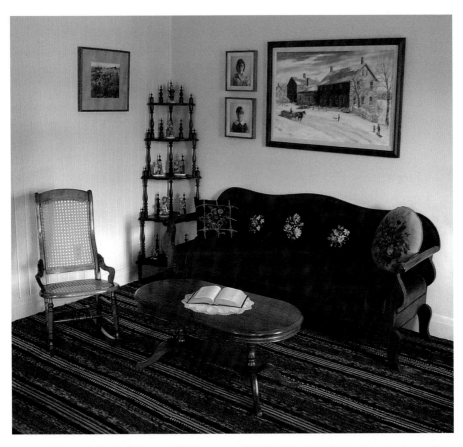

Traditional Amana Style Living Room

These photographs show rooms in Adoph and Ruth Schmieder's home in Middle Amana. For generations, Amana residences had hand-woven floor coverings in striped patterns made from wool manufactured in the woolen mills. The bird's-eye maple chest-on-chest, opposite page, came from Germany in 1844. The platform rocker and straight chair, left, and cushions on the davenport, above, have needlepoint by Ruth's mother, Johanna Jeck Herrmann. The furniture above came from the Amana Furniture and Clock Shop. Hummel figurines are on the what-not. Ruth is noted for her oil paintings and miniatures. Her painting above the davenport depicts their home in Middle Amana. The portraits of their grandchildren, Rebecca and Sarah Roemig, are by Robert Bauer, who lived and painted in the Amanas during the 1970s.

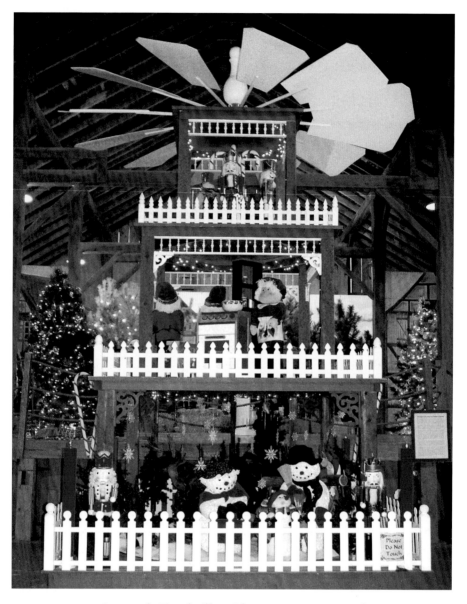

Amana's **Festhalle** *Christmas Pyramid*

Pyramids were a tradition in the Saxony region of Germany, home to many of the Amana forebearers. Sizes vary from two feet to this revolving fifteen-foot pyramid built by a group of Amana craftsmen for the *Festhalle* display. The Amana Arts Guild teaches pyramid building.

Christmas Traditions

In the early years of Amana there was a period of time when Christmas trees were forbidden because they were considered too worldly. Gradually the elders relaxed these restrictions. In the late nineteenth century, Christmas trees in communal Amana were not really trees, but, instead, consisted of a wooden pole with holes drilled in it, mounted in a base. The family would insert small pine branches into the holes, thus forming an early type of artificial tree. The tree would be decorated with small candles in tin holders, as well as with blown glass ornaments, painted nuts, and other items from the village general store. In other cases, a family purchased small artificial trees fashioned from painted feathers to use as a Christmas decoration. At the base of the tree the family often created miniature scenes using small animal ornaments and wool batting.

Traditionally, the gifts for children were arranged unwrapped around the base of the tree to await the signal on Christmas Eve when the children would be allowed into the family parlor to see the tree and their presents.

Giving gifts to children at Christmas was secondary to the religious importance of the season. Even so, the fathers and husbands devoted many free hours in a cabinet shop making wooden toys for the children. Handmade sleds, wheelbarrows, wagons, kiddie cars, and scooters were crafted for the boys, as well as small hand-carved figures such as soldiers and animals. Doll houses, complete with many pieces of intricate miniature furniture, were made so the little girls could play house. The one-year-olds frequently received pull toys and beautifully made rocking horses. One of the toys most enjoyed by both girls and boys was the *Klickerbahn*, a wooden toy with a track for marbles that were directed downward to hit a bell at the end of the path. These are still made for the young in Amana today.

A special tradition still observed in many Amana homes is that of the Christmas pyramid. Pyramids are built of wood with candles arranged up the sides. When the candles are lit, the heat rises, causing the fan at the top, which is connected to round platforms in the middle of the structure, to rotate.

This tradition can be traced to Saxony, the home region for many Amana families. The earliest extant pyramid, made in the 1870s, featured paper paddles and was used by the Fehr family of Amana.

In more recent years, woodworker Harvey Jeck of High Amana has fashioned a number of pyramids, some of them over five feet tall. A special commission resulted in the construction of a sixteen foot motorized pyramid that is displayed in the Amana *Festhalle* Barn during its annual *Tannenbaum* Forest in November and December.

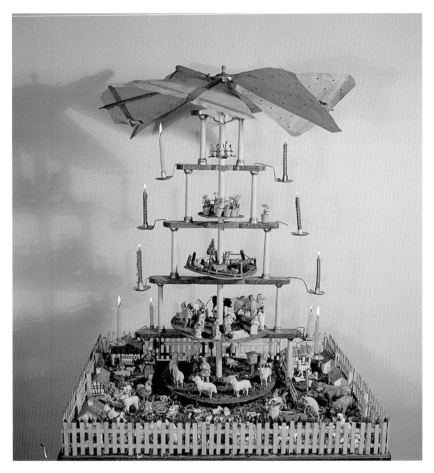

This fragile pyramid with paper paddles was used by the Fehr family of Amana and is now a part of the Christmas display at the Amana Heritage Museum.

Another, less common, Christmas decoration used in Amana and also derived from Saxon origins is the Christmas *Leuchter*. Essentially a large horizontally hung wreath with candles, the *Leuchter* was suspended in the center of the family parlor during Christmas and was decorated with ornaments and candles. A single original *Leuchter*, made in Middle Amana by cobbler Emil Jung (1857–1895), survives today.

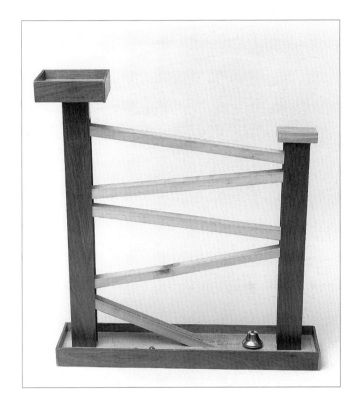

The Klickerbahn

This is a popular marble machine built by Amana woodworkers.

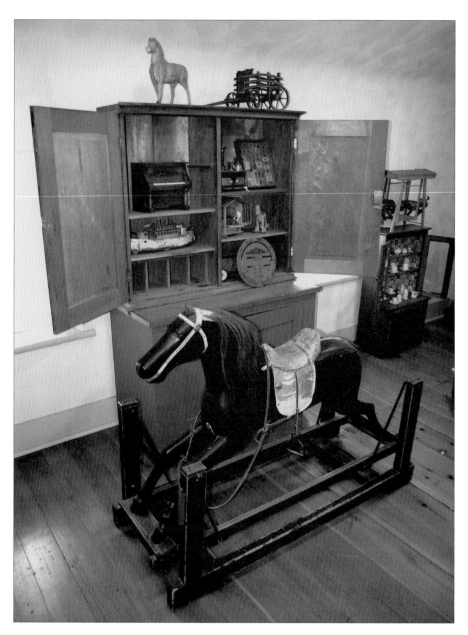

This large rocking horse made by noted Amana clock maker Friedrich Hahn is featured in a display of toys at the Amana Heritage Museum. By the early 1900s, Amana children played with store-bought toys as well as handmade games, tops, dolls, and doll houses.

Back to Beginnings

By Madeline Roemig Bendorf

Madeline Roemig Bendorf grew up in Amana. Her great-grandparents were born in Germany and were Inspirationists who made the journey to New York. Madeline is a founder and past director of the Amana Heritage Museum.

I have been to Germany three times. Somehow it seems we are linked closer than the spread of three generations, probably because so many of us live together in Amana and are able to practice the German language, and because our villages resemble the German villages our people left behind.

The language made the first impact on me. Arriving at the Frankfurt airport, I could read the signs! Listening to the chatter around me I thought, "They all speak German. Even the little children speak so well." Using our Amana German is tremendous fun. Sometimes I am mistaken for a native, or asked which region I am from originally.

I looked for the familiar and found it. In one place we had *gefüllte nudeln* (filled noodles) served with applesauce just like my mother made. The soups with dumplings and the boiled potatoes, asparagus, and ham were like eating at Oma Schmieder's table again.

Common features abound: the locks and latches on doors, the lines on pieces of furniture, the flower gardens, the vegetable gardens plant-ed in such neatly spaced patches and beds. I look at these things and realize why our gardens, furniture, and door locks are as they are.

In small villages, woodsheds with neatly stacked piles of kindling reminded me of that part of my home in Amana which in later years became a garage. The presence of large barns in our Amana villages is something I like very much.

A most pleasant experience on an early morning walk in Oberammergau occurred when I wandered into a dairy barn where a few cows were being milked by the farmer. I asked if I might watch, and he nodded agree-ment. In addition to seeing this sight, the smells, clean and sweet, were

transporting me back to our Amana dairy barns in the center of town, where as children we were allowed to enter and observe when we felt like it. As was the one in Oberammergau, ours were immaculately clean.

The cleanliness and orderliness of Germany is seen everywhere, and it struck me at once why we in Amana are that way. When apples fall from the trees, they must be picked up and used. When the wind downs twigs and branches, out come containers and saws, and the cleanup begins as the wind ceases. That is why we air our quilts and carpets, sweep sidewalks, and scrub floors as compulsively as we do.

Amana people have made many pilgrimages to the castles and estates where our ancestors gathered before emigrating to America. These are located in Hessen near Budingen, all spaced a short distance apart. It is stirring to stand in courtyards and among ruins where our history began. It is as if the walls and ground should be able to speak to us.

Most memorable is the moment when the Ronneburg castle comes into view. It sits on a hill, and the approach to it is as beautiful as the castle itself. It is unmistakable because pictures of that landmark are in almost every home in the seven Amana villages. Engelthal, a cloister, has a hush and quietness befitting the spot, and invites one to imagine people living there with names such as Roemig, Dietrich, Marz, Moershel, Zimmerman, etc. At the Arnsburg, the shadows cast by the walls of the ruins reminded me of the passage of time, and of the fact that no matter what the length of time, something draws us back to beginnings.

One of our Germany trips was with a group of Amana people that included my Aunt Magdalena Schuerer. One of my fondest recollections is that she (Magdalena Oehl Schuerer) and I (Madeline Oehl Roemig) stood together, silently, near the great Rhine Falls in Schaffhausen where our ancestor Magdalene Muller Roemig was born.

There is a *Freilichtmuseum* (open-air museum) named Hessenpark near Neu, Anspach, which is near Frankfurt. It is an entire village reassembled to portray a typical Hessian village of the nineteenth century. One of the buildings is devoted to telling the stories of people who emigrated from Hesse to other parts of the world, exploring where they went, how they fared, and what remains of these people today. I helped assemble material and objects for an Amana exhibit in the museum, and was present in

1983 at the dedication of the building and exhibit. Some of the things our forefathers brought from Hesse have thus returned home and are part of a story being told in Germany each day.

Under the leadership of Professor Eugen Ernst, the museum continues to grow. It is a place in which farm animals, storks, and wild flowers live alongside wide buildings and objects of the past. Among attractions are an excellent restaurant, a hearth oven bakery, a performing stage, and a pottery and brick kiln.

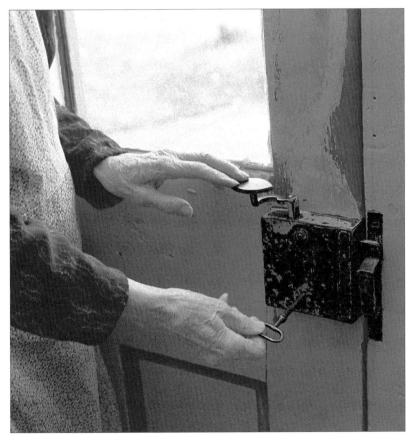

This lock made by an Amana locksmith for the front door of the High Amana General Store is similar to those Madeline Roemig Bendorf found in Germany. Many of the original door latches are still used in Colony homes and businesses.

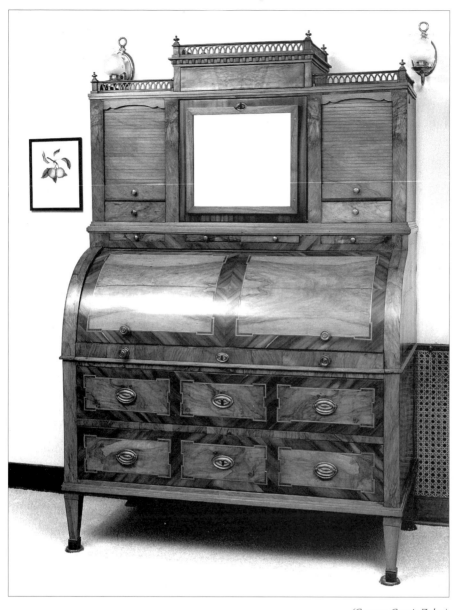

Secretary

This imposing piece was brought from Germany. The cabinetmaker incorporated numerous construction techniques and kinds of wood. The interior has many secret compartments and other divisions of varying sizes. On the wall is a Prestele lithograph of fruits.

Furniture and Woodworking

Origins of Amana Styles

The origins of Amana furniture design are numerous, and at times somewhat unknown. The furniture moved to the castles and monasteries in Hesse was from a cross-section of the population and from different parts of Germany and surrounding areas. Many of the chairs, tables, and other pieces owned by the less prosperous were relatively primitive, simple in line, and roughly assembled. On the other hand, families of greater wealth brought furniture that had been crafted by skilled cabinetmakers and showed considerable refinement both in structural and decorative design.

Furniture needs were considerable when the Inspirationists first arrived in upstate New York. Woodworkers, carpenters, cabinetmakers, and others quickly met the demand. Of necessity, the furniture had to be simple, easily crafted, and functional.

With the move to Ebenezer and later to Iowa, the exposure to and influence of new and different styles gradually crept into furniture designs. The Inspirationists undoubtedly were influenced by the furniture of the Dutch, English, and other German settlements in upstate New York.

Furniture in the Castles and Monasteries

Some of the more affluent Inspirationists moved many of their ornate desks, chairs, and chests to the castles and estates of Hesse. These pieces often had elaborate inlay, brass mounts, combinations of woods, and intricate detail. However, most of the furniture of the less-affluent members was simple in line, strong, durable, quickly assembled utilitarian chairs, benches, stools, tables, and beds without ornamentation and made from native woods. Both the ornate furniture, known as *Biedemeier* in Germany, and simpler forms played a role in the style of the furniture that was to evolve and eventually be built for the people of Amana.

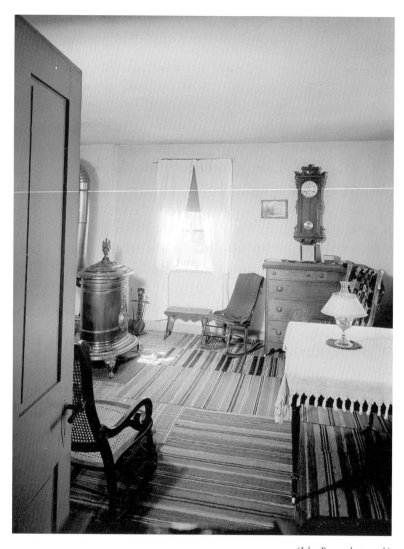

An Amana Living Room

Many Amana living rooms remained largely unchanged for several decades after home ownership came with The Great Change. Note the wood stove, clock, handwoven carpet, caned rocking chair, chest, and table in the traditional style in this 1937 view of a living room. House blessings, Prestele lithographs, and watercolors could often be seen decorating the walls.

Amana Chairs

The basic chair style that has been popular in the Amanas throughout the years is the spindle back, a chair style sometimes referred to as a "stick" chair. It was built with many variations and used in the homes, hotels, and workshops. The side chair has a series of vertical spindles as a back support with a solid rail across the top, a shaped seat, and four turned, splayed legs connected with stretchers. It was traditionally painted black and often with a narrow yellow line about one inch in from the edge of three sides of the seat. Surfaces were painted rather than with natural wood finishes possibly because paint was more durable and less expensive and would camouflage the grain of lesser-quality woods.

The spindle backs of Amana had many characteristics of the early Windsor chairs. Old European household inventories suggest that the beechwood spindle back was developed in and around Windsor, England, about 1675, with the design credited to the men who made and repaired wheel spokes, the wheelwrights. There is also evidence that the spindle backs may have been developed independently on the European continent—a painting produced in Germany in 1739 shows two spindle back chairs similar to those produced in England but with more elaborate rails atop the spindles and raked legs.

In about 1875 a new style of country cottage furniture was introduced in England through Godey's Lady's Book as well as by designer George Lock Eastlake. Shortly, thereafter, this style of well-liked country furniture was carried to America and gradually produced in many areas of the country, including the Amanas. The style uses simple turning, straight lines, panel construction, and rectangular structure. A typical chair, known today as the Eastlake chair, has a slightly concave back formed by two tiers of spindles. It is supported by square, slightly flaring uprights with rounded ends and is joined to the seat by short, open brackets. The tapering front legs have ball and ring turning. This chair has been one of the most popular chairs made and marketed in Amana.

The armchair version of the Windsor, or spindle back, also became a standard in Amana and elsewhere. It has a heavy horseshoe-shaped continuous arm that curves down to the seat and is supported by seven or nine Windsor-like turned spindles. The seat is U-shaped. The legs are

slightly splayed, with the back and side stretchers plain, and the front legs and stretchers ring turned. This chair is sometimes referred to as a "captain's chair" or a "firehouse Windsor," because it was a style commonly found in the firehouses of Philadelphia and made by the German cabinetmakers in that city during the early eighteenth century and onward.

Amana-made examples of such chairs date back to 1875 and are still used extensively. These chairs, like the side chairs, were traditionally painted black. Highchairs for young children had spindle backs and arms, as did the chairs created for those who were invalids.

Chairs of this general type were meticulously crafted also for the *Werkzeuge* Christian Metz and his successor, Barbara Heinemann Landmann. The Metz chair has a little more detail with spiral turning on the legs, spindles, and front stretcher. This chair was handed down in the Metz family and signed on the underside of the seat with the dated signature of each descendant who received it. Both the Metz and Landmann chairs are now in the collection of the Amana Heritage Society.

Another chair style, known as the Amana rocker, is a classic and popular handcrafted chair form made for use in the Amana Society as well as for sale outside. This has characteristics of the Biedemeier style and seemed particularly comforting and soothing to the *Opas* and *Omas*, especially after a day of tiring labor. A few of this style were transported from Europe to Ebenezer and later to Iowa with reproductions being made along the way. The turned legs and stretchers are similar to other chair forms, however, the addition of pronounced curved arms changes the appearance considerably. Both the back and seat are caned.

Footstools were often placed next to the chair. They were usually round, twelve to fourteen inches in diameter, and short in stature with a solid exposed hardwood top or top covered with a little padding and durable upholstery fabric. The legs were flared and required only small amounts of wood; it is likely they were crafted from pieces left over from larger projects and thus shaped and turned accordingly. Amana cabinetmakers made some of the footstools; others were made by men who enjoyed woodworking as a hobby. Note the footstool shown on page 34 in the Schmieder living room.

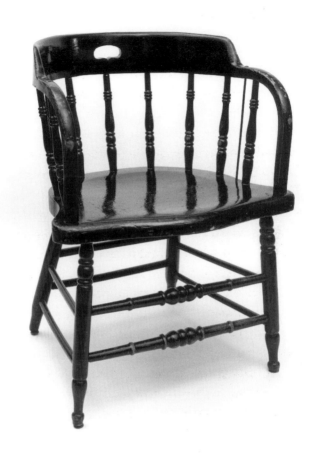

Painted Pine Arm Chair

Chairs of this style could be found at Zuber's Restaurant, housed in a former hotel in the village of Homestead. The design of the Windsortype chair, often called a captain's chair or a firehouse chair, was brought to America by early European settlers and reproduced throughout New England and the North Atlantic states, especially in the city of Philadelphia, the home of many skilled German cabinetmakers.

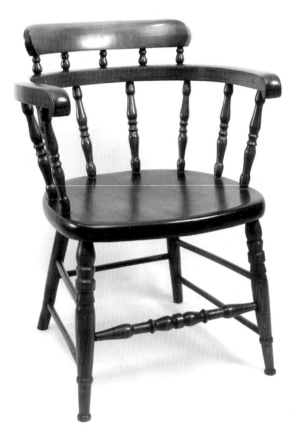

The Christian Metz Chair
Above: *This chair was made especially for and used*
by the Werkzeug *Christian Metz.*
(Courtesy Theo and Helen Kippenhan)

Opposite page: *The walnut youth chair, upper right, incorporates*
details found in Amana chair designs of an earlier day with a spindle
back, simple turning, splayed legs, and bracket support.

Norman Schanz, left, and his son Mike, right, are fifth and sixth-
generation family woodworkers. Shown in the South Amana workshop
of the Schanz family are also Mike's three sons. The Schanz family
specializes in new furniture, reproductions, and refinishing. Norman
built chairs to specification and other reproductions for the Old Capitol
restoration in Iowa City.

50 —

Youth Chairs

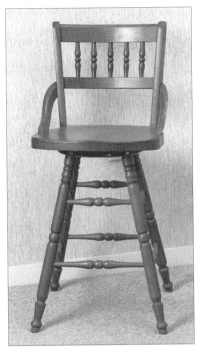

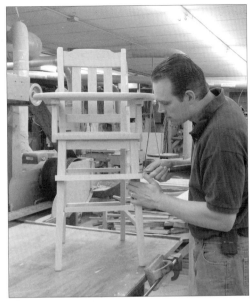

Mike Schanz creates a highchair in the Schanz workshop.

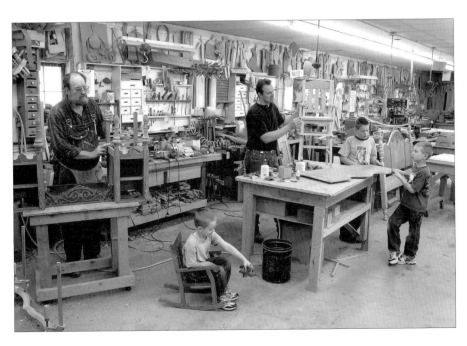

Sofas and Other Basic Seating Pieces

In addition to the chair, rocker, and occasional footstool, a living room of the early Amana days probably would have been furnished with a sofa, chest-on-chest, table, hanging wall clock, and a newspaper rack. The rag rugs, blue calcimine walls, and white cotton curtains at the windows softened the background and provided some added warmth. The early sofas could not have been very comfortable, but styles tended to become less severe as time and materials became more plentiful.

One early form of sofa had a straight back and solid plank seat, squared arm, and no upholstery. It was more of the style that is thought of and used today as a porch bench. Another early form had a thin padding covered with a coarse textured upholstery fabric on the front of the back with bare wood on the reverse side. The seat was exposed wood.

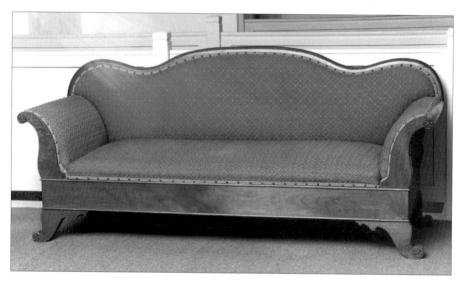

Amana Style Sofa

Above: This basic style reflects strong Victorian (serpentine-arched top rail) and American Empire (half-lyre-curved ends and bracket feet) influences. The rails, ends, and apron have exposed wood. The upholstery is attached with long-shank upholstery tacks.

Opposite page: Great-great-grandchildren of religious leader Christian Metz sit on an Amana sofa in 1915.

The style of sofa most commonly associated with the Amanas was quite different, but one that is often considered a standard of the Amanas of the past. It is characterized by its plain, beautifully hand-finished exposed walnut or cherry along the front apron and back serpentine rails, and out-curving arms and legs. The seat and back were stuffed with horsehair and upholstered in a heavy fabric of solid color. The half-lyre arms and curves of the rail add a softness to the otherwise rather heavy piece of furniture.

The design of this Amana sofa belongs to the early American Empire period, which first appeared in England. It was possibly introduced with the arrival of some latecomers through their observations and possessions. There were few other outside influences as the people of Amana subscribed to a restricted number of newspapers and books, including a few professional or "how-to" publications. Some of the later cabinetmakers may also have been men with a special interest in the design and construction they saw while traveling. As the Society members gradually moved away from their earlier furniture forms, upholstered seating pieces took on a new look, and new styles replaced the horsehair padding with springs and various combinations of foam. Today, the Amana furniture shops handcraft only those pieces of furniture that are produced of solid wood.

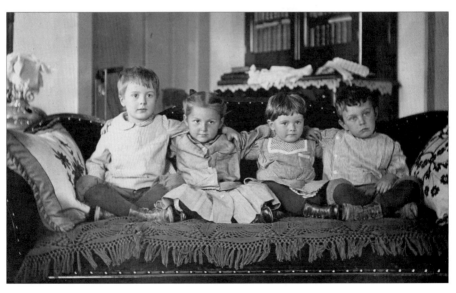

Benches

The Amana church benches are especially interesting and attractive in form. They were long, plain, and simple in design and might well fit into a minimalist or contemporary setting of today: plank seats, a narrow rail atop the back vertical supports, and tapered legs, without soft, comfortable upholstery that might be conducive to a short nap during a service. The pine used in their construction came from Society-owned land in Canada. Most of the seat planks are more than thirteen inches wide, and some benches are longer than twenty feet.

The basic form of these benches is still to be found in Germany today. When transported from Ebenezer to Amana, the seats, backs, and legs, held together with wooden pegs, were disassembled and then reassembled. These benches remain in continuous use by the Amana Church today. Other church furnishings were mostly without color except for the rather subdued blues and browns woven into the rag carpets and a dark green square of baize that covered the table placed in front of the elders.

Other simple, unpainted, backless wooden benches served as handy, quickly assembled utilitarian seating pieces in many work settings.

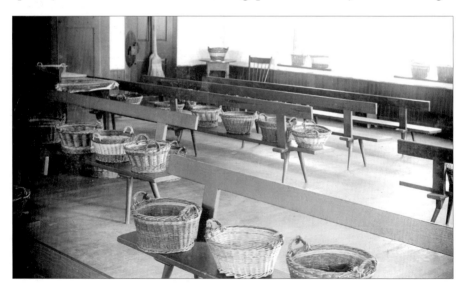

School House Benches and Knitting Baskets
Communal Era, 1892

These benches did not have four separate legs, but instead a piece of plank attached to the seat at a right angle, and an inverted "V" sawed out at the base. The women preparing cabbage for making sauerkraut sat on them in the communal kitchens and the men sat on them while eating their noon meals. The clock makers would spend endless hours sitting on them while assembling clock movements. Many a family member considered such a bench a necessity for frequent back porch neighborly visits.

A more refined multiple-seating-type bench, the garden bench, which was very comfortable and popular, followed. The front, seat, and back formed a continuous free-flowing line from the front edge of the seat to over the top of the back, and was made up of a series of parallel horizontal slats or strips of wood. Much later came the deacon's bench, with a wide seat, spindle back, broad top rail, and simple turning on the legs and stretchers. Lawn swings, or gliders, were also added after a few decades.

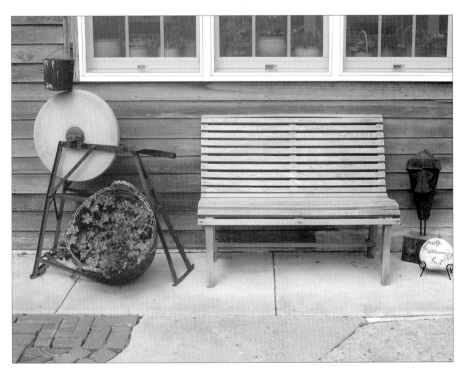

Garden Bench
Entrance, Gordon Kellenberger residence, High Amana

Schranke, Chests, Tables, and Desks

The Amana home had an aura of warmth and security even though the furnishings were sparse, straight-lined, and without the "gingerbread" frills found on Victorian pieces of the same era. A part of this warmth was created by the mellow look and beautiful treatment of the fine-grained hardwoods, especially noticeable on pieces of furniture which had large panels, such as the table tops, chests, and tall wood double doors on the front and sides of the storage pieces known as *Schranke.*

During the communal kitchen years, tables for the homes were small and square as they were not used for family meals but, rather to hold an oil lamp, maybe a plant, or a memento or two from Germany. The basic design remained the same for many years. As time passed, meals were brought home and eaten there rather than in the communal kitchens.

A style of table popular in the surrounding farm community and that became common in Amana was a round table that had two drop leaves and no drawers. These tables had some ring turning on the straight legs and white porcelain casters so they could be easily moved for cleaning.

As needs changed, five-legged round gateleg tables were added, as were rectangular harvest tables with regular or long drop leaves extending down toward the floor.

Panel construction of the front doors and sides of the tall, imposing, impressive two-door chests, *Schranke,* also provided long expanses of wood ending with modified bracket feet. Some had exterior wood surfaces sanded and finished seven times, others were simply painted. On the interior was an attached horizontal board with wooden pegs for hanging clothes. Like the homes they had left behind in Germany, the new homes built by settlers had no built-in closets, and for this reason the wardrobe storage units could be found in every home, school, and meetinghouse.

Chests were important to the Amana people. At the time of the moves from Europe and from Ebenezer to Amana, many were built to hold supplies and clothing. Some were rather rough hewn; others had a more refined appearance.

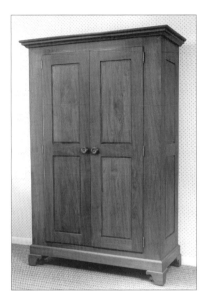

Schranke
These large wardrobes were used for hanging clothing and storing trunks.

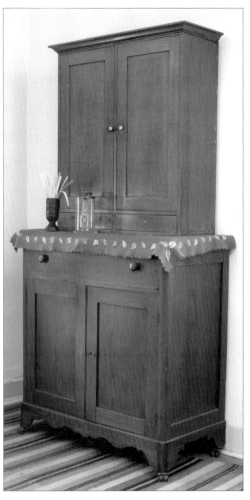

Chest-on-Chest

Right: *A piece of fabric, such as dark green baize or a crisp white cloth trimmed with a crocheted edge, would be placed between the upper and lower sections or on the front shelf created by the difference in depth between the two sections.*

The device seen near the center of the shelf is a Zindt machine, or ignition machine. The turned wooden holder on the left contains paper tapers, which would be ignited by the machine to light lamps, pipes, and stoves.

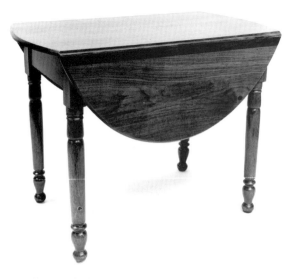

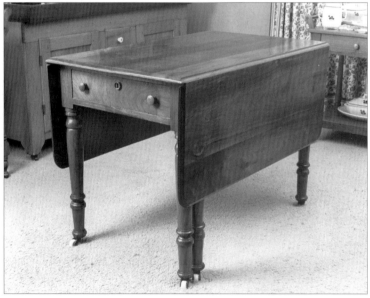

(Courtesy Connie Zuber)

Above: *This walnut drop-leaf table was repaired and refinished with curved drop leaves by Schanz Furniture and Refinishing Shop. The center leaf is fixed and there are no drawers.*
Below: *This old traditional Amana gateleg table has porcelain casters. The components of the drawers have dovetail joints and the legs are joined to the frame by mortise-and-tenon joints.*

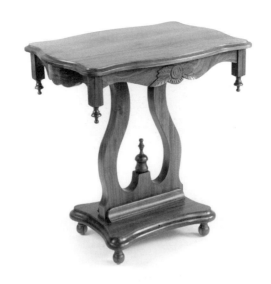

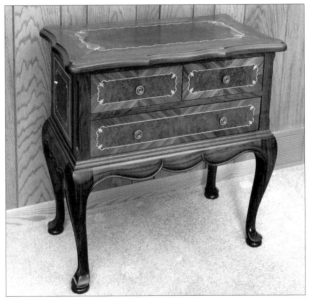

Above: *This Southern Becky Lee table, originally made by request, is from the Krauss Furniture Shop in South Amana.*
Below: *A made-to-order three-drawer walnut low chest with design influence of the Queen Anne period. The chest is made with a combination of different woods and surfaces enhanced with marquetry.*

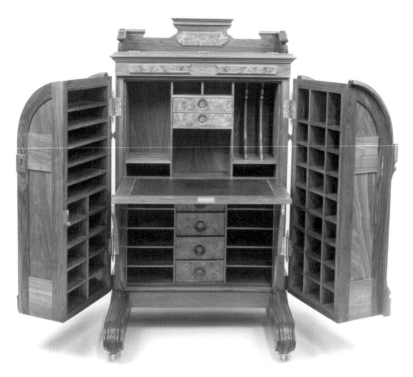

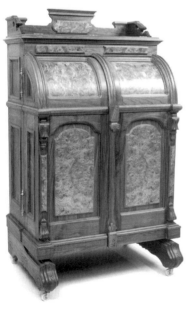

A desk of this design, patented in 1874 by W. S. Wooten, enabled one-man businesses to store all their records in one place. This reproduction, made by Schanz Furniture and Refinishing Shop, is made of solid walnut and Carpathian elm burl. The doors are dovetailed, the wood finished with a four-coat, hand-rubbed finish, and the brass is of European style.

Four-drawer Commode with Wooden Pulls

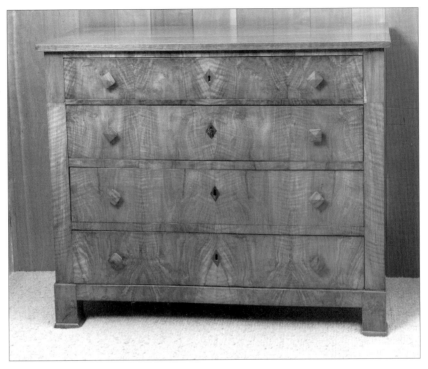

This pine commode was brought from Germany by the Winzenried family, ancestors of Connie Zuber of Homestead. This furniture once belonged to a manufacturing family in Liebloos, Germany, who joined the Inspirationists.

Beds for Sleeping and the Eternal Bed

Bedroom furniture usually consisted of two single beds, a commode, a washstand, a night table, and a side chair or two. The beds were of a variety of plain-panel styles with matching headboards and footboards and four turned posts with finials. One style, commonly referred to as the "Ebenezer bed," was especially popular.

The beds were typically of the same height and shorter in length than the standard mass-produced beds of today. Sectional mattresses of horsehair or twisted hog hair were supported by ropes knotted in a square pattern that were attached to the frame with pegs. Later bed frames supported the mattresses on wooden slats.

Typical Beds, Then and Now

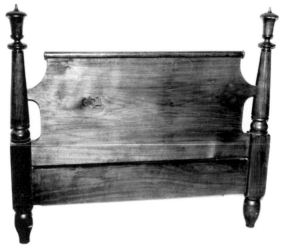

This Ebenezer-style headboard is available upon request
in most Amana furniture showrooms.

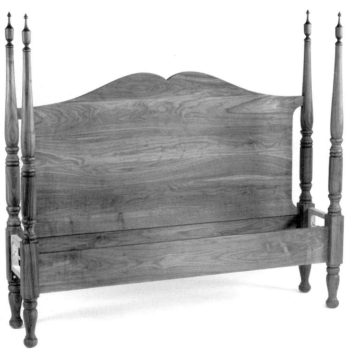

Four-poster headboard, a popular piece in many Amana homes today.

Soft feather ticks, feather pillows, and comforters offered a pleasant contrast to the clean-cut, somewhat rigid look of the furniture. The cabinetmakers of the Amana furniture shops today still make the Ebenezer-style beds as well as taller four-posters and other styles when requested. Other than the beds, most pieces of furniture were created as singles rather than in matching pairs.

When a baby was born, a cradle was brought into the household. Many were passed along to families and friends as needed. The ends of the cradles are solid panels somewhat similar to the adult beds with a series of turned spindles on the side. While the baby was still an infant, a pair of rockers was temporarily added at the base of the legs. When the child was a little older and the rockers were no longer needed, they were removed so that the bed would become stationary and serve as a youth bed.

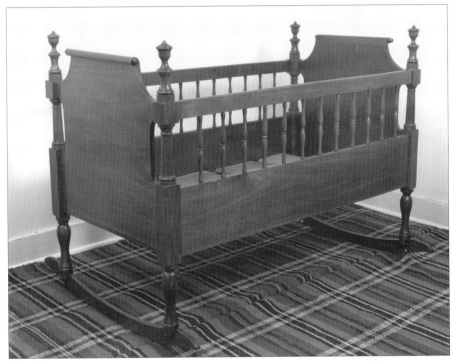

(Courtesy Connie Zuber)

A baby cradle rests on Amana carpet.

The Cooper's Collection: This is a new design by David Rettig, manager of the Amana Furniture and Clock Shop.

The Eternal Bed

The last resting place of an Inspirationist was a coffin made by the cabinetmaker. In the belief that all Society members are equal, every coffin was constructed in the same manner and style as every other coffin. The idea of equality was carried into the cemetery. People are buried in the order of death, not in family groupings. Each plot is the same size as that on either side, and each concrete grave marker was identical to every other one in the cemetery. An exception was that of Christian Metz, whose burial lot is twice the size of the others. The rows of beautiful tall pine trees and rows of white markers express a peacefulness and solitude that is symbolic of the simple religious life of the people buried there. Members of the Amana Church Society are still buried in identical pine coffins made by the Amana Furniture Shop. Since 1934, the lids of these coffins have been constructed in two sections, rather than a single solid lid, and metal handles have replaced the original wooden

handles. The sides of modern coffins are straight and not angled as previously. Since 1932 the deceased have been embalmed. While friends and family used to pay their respects in the family home, today this is done in one of the church anterooms. Burial is still in chronological order of death, and members receive identical gravestones, noting their name, date of death, and age.

The Cabinetmaker, a Skilled Craftsman

The Inspirationists considered cabinetmakers and woodworkers of vital importance to the Society and recognized the worth of passing the skills on to succeeding generations through apprenticeships and training. The cabinet shops and tools were always available for older boys and interested individuals. The woodworkers, along with other artisans such as the basket makers, tinsmiths, coopers, blacksmiths, and rug weavers, passed their interests and expertise to their offspring.

Society artisans maintained high standards and sought a perfection and beauty in the cabinetry that has become their trademark. The furniture, then and now, was made of choice woods with time-proven techniques of precise dovetailing, mortise-and-tenon, tongue-and-groove, and dowel joinery. At no time has furniture been finished with a distressed look to appear antique. Amana furniture features clean lines, few veneers, little molding, no beading, and relatively little carving.

The glue used in the early days of Amana was purchased outside the community and prepared and sold by a Cedar Rapids meatpacking company. Animal parts such as hoofs, bones, ligaments, and tendons were boiled in a solution to produce a gelatinous adhesive liquid that had considerable strength for adhering one piece of wood to another. The final process that was used and continues to this day is the application of a hand-rubbed finish. A number of coats of filler, sealer, and varnish were applied by brush, hand-sanded, and the surface rubbed to a satiny patina.

On occasion a single cabinetmaker would be responsible for a particular piece; other times one cabinetmaker would do the turning, another the joinery, and so on. Furniture makers, in keeping with Inspirationist ideals of humility, did not sign their work, although pride in craftsmanship sometimes led a few of them to sign their names in an inconspicuous place that would later be covered with upholstery

or molding. The cabinet shops were plain and unaffected by many of the technologies of the Industrial Age.

Beyond producing furniture for the home, Amana cabinetmakers were also responsible for making many of the wooden tools used by community members in their daily lives. These items ranged from wooden wheelbarrows for the farms to ladles, spoons, and drying racks for use in the communal kitchens. Lap trays were special items made for the women working in kitchen houses. Known locally as *"Rüst Brette,"* the kitchen workers used them when they sat outside to peel potatoes, snap beans, and prepare vegetables for cooking.

Christian Metz, the *Werkzeug,* was among the numerous skilled cabinetmakers and woodworkers. He learned the woodworking trade as a young apprentice from master craftsman Jakob Mörschel (1781–1852). His skills appear to have been mainly in carpentry, rather than in furniture making, because no known examples of furniture made by him are known to exist. Metz reportedly planned the entire floor of the High Amana Meetinghouse when it was constructed in 1858. The Inspirationist leader continued to use his skills to aid the community in addition to his religious and business guidance.

After the transition from communalism to capitalism in 1932, outsiders tried to buy furniture pieces brought from Germany as well as pieces handcrafted in the Amanas, most of which the Inspirationists were not anxious to sell. By the 1950s demand for handcrafted Amana furniture caused many cabinetmakers as well as other artisans to establish their own independent business operations. The tradition continues with furniture styles of the past as well as more current styles being made available. The cabinetmakers are also happy to fulfill special orders to meet the requirements of a customer with wood either supplied by a customer or the cabinet shop.

Friedrich Hahn, Clock Maker
(1843–1919)

The legend of Cinderella is a fascinating story that emphasizes the importance of time. The story is about a poor little waif, magically changed into a beautiful princess who attended a wonderful ball with her Prince Charming but, because she was not punctual in returning home at the stroke of midnight, was returned to her earlier state of rags and poverty. Perhaps the outcome might have been different had she been able to hear the chimes of a Hahn clock.

Timekeepers of the Past

Timekeeping devices have been in place for many centuries. The shepherds of long ago predicted the onset of dawn and dusk by studying the position of the moon and stars. Subsequently, the length of the shadows on the sundial was a measure of time, but only during the daytime when the sun was shining. Later, the Egyptians developed the water clock, an innovation that had the limitation of working in warm, but not freezing, temperatures. Other advancements followed. In the seventeenth century a German clock maker from Nuremberg introduced the revolutionary spring-driven long pendulum. Most Germans became more and more interested in clocks and were very conscious of being punctual. This German attribute placed an added emphasis on the importance of clocks.

The Hahn Family: Ebenezer to Ohio to Ebenezer to Iowa

Friedrich Hahn was born on June 1, 1843, in Langensebold, Germany. When he was just two years old, his family moved to one of the Ebenezer villages, arriving on August 7, 1846. The father, Friedrich Hahn, Sr., soon decided that the religious regimen was too strict and that he should move his family elsewhere. As they were ready to leave, Christian Metz delivered an inspired testimony that declared, "I shall come towards you as an armed giant and will press your strength into the dust." Hahn disregarded the words of Metz and early in the following year, after the family had

Left: *A clock made by Friedrich Hahn*

Right: *A modern reproduction of a Hahn clock from the Amana Furniture and Clock Shop*

moved to Ohio, he was crushed by a falling tree. The unfortunate inci-
dent had the effect of reinforcing the religious faith of Hahn's wife and
children as well as that of the Society members back in Ebenezer. They
rejoined the believers in New York and those living in the Ebenezer set-
tlement at Kenneburg, Canada. In 1857, the Hahn family joined the
migration to the new settlement in Iowa. They were assigned a house in
High Amana, where the mother, Marie Trautmann Hahn, became a
Küche Baas (kitchen boss) in one of the communal kitchens.

His Early Training and Work

Like other young people, Friedrich, undoubtedly, had the basic eight
years of education in the village schools. He had an inquisitive mind. The
elders assigned him work in the machine shop of the Middle Amana
Woolen Mill, where his mechanical aptitude and talent led him to build
and learn to maintain machinery. He also became a land surveyor. In
1871 he married Louise Meyer, with whom he later had three children.

An accident with a horse and wagon left Hahn unable to continue
strenuous physical activity and led to his more sedentary lifestyle as a
clock maker. Like so many of the other versatile young men of the
community, he enjoyed making handcrafted furniture and became
well-known for his skill as a cabinetmaker. His cabinetmaking skill and
his technical know-how led him to develop and perfect an inter-village
telephone system for the Society from plans he had found in *Scientific
American*, only five years after Alexander Graham Bell invented the
telephone. Hahn's wall-mounted business and residential telephones
had a crank on the side for "ringing" the operator and two silver bells
mounted on the top.

Clocks in the Hahn Style

Little is known as to how Hahn learned the art of clock making. Perhaps
curiosity caused him to dismantle a family clock, or possibly he learned
it from reading *Scientific American,* one of the few periodicals the
Society subscribed to and which Hahn faithfully read. It was said that
he would pick up the monthly as soon as it arrived at the post office and
was instrumental in having the copies bound for later reference.

In addition and as a hobby, he made toys such as doll houses, rocking horses, and a violin, although Society leaders discouraged playing musical instruments. He loved to sing, had a good singing voice, and served as a song leader in church. Throughout his lifetime he had the same dedication to his religion as his mother, and became a church elder in 1887 and head elder for Middle Amana in 1913. He stood six feet tall, was very kind, and so religious that he often wept during services.

Clocks were becoming more important both in Europe and on the American frontier. Soon wall-hung clocks and shelf clocks were a common item in most Amana homes. Among other things, no one wanted to be late for church services!

Hahn made some fifty to seventy clocks, all similar in styles to those of the well-known Vienna regulator clocks of Europe, between 1800 and 1900. Most were hanging wall clocks of the same basic structural design, but with some variation in the simple, sometimes carved, decorative design on the crowns and finials at the top. They were usually three to four feet high, approximately a foot-and-a-half wide, and made of choice walnut. Hahn used traditional mortise-and-tenon joinery in assembling the wooden components. The front panel and two side panels were of plain glass with no etching, the "style of the day" elsewhere in America during the Victorian period. Hahn assembled his own clock works, combining parts he made himself with gears and shafts purchased from commercial suppliers. The dials and hands of his clocks showed the trademarks of two American manufacturers: Ansonia and Waterbury. His clocks strike on the hour and have a bell-like sound on the quarter hour.

A traditional Sunday morning chore of the head of the household was to wind the clocks to assure promptness for worship and work the following week. The village bells, rung promptly at 8 a.m. on Sundays were used to check the accuracy of family clocks. The resonant ticking provided a feeling of security and comfort with a degree of nostalgia during the long hours of darkness in the winter.

The Vienna regulator clocks had Arabic numbers, while many of the others had Roman numerals. The Roman numeral IIII was used instead of IV, as the former would tend to visually balance the halves on the face of the clock. The Hahn pendulums have plain black shafts to support

the large round brass, eye-catching body that swings freely to-and-fro under the action of gravity to regulate the movements of the clockworks. The unencumbered simple lines of the cases enhanced by the beautiful finish of the walnut wood, plus their accuracy, made them all cherished possessions. The Hahn clocks were made in the quiet of Hahn's bedroom, not in a community workshop, as were the crafts of many other artisans whose work did not require extensive space or equipment. Each morning, Hahn's wife, Louise, covered his bed with a sheet to keep any metal shavings or sawdust from landing on the bedding. Hahn continued to make clocks until his death in 1919.

Hahn was not the only clock maker in communal Amana. Prior to 1920, the Amana Society operated a clock and watchmaker shop in Main Amana. While much of the activity in this shop involved the care and repair of clocks from the seven villages, the craftsmen who worked there also produced new clocks for Amana homes. Carl Trautmann (1830–1919) made several small shelf clocks still in use in some Amana homes today. Fritz Fröhlich and Friedrich Jeck (1821–1906) were two other long-time Amana clock and watch makers, although very little is known about this small Amana craft shop today.

Many individuals followed the footsteps of the early Amana clock makers at the Amana Furniture and Clock Shop. One was Clarence Oswold, a plumber of Norwegian descent who had learned woodworking as a hobby and had had minimal exposure to making clocks. The former plumber and his wife did not come to the Amanas as Inspirationists, but, instead, as tourists. After a visit they decided that a move to the Amanas would be right for them with the possibility of the husband beginning a new career as a clock maker. In the years following that day of decision, Oswold made 1,713 clocks, some seven-foot-high grandfather or tall-case clocks, and some six-and-a-half-foot grandmother clocks. Following his retirement, he continued to make smaller shelf clocks, and, along with his wife, learned to cane the backs and seats of chairs. Numerous other clock and watchmakers preceded as well as followed him in several of the villages. They enjoyed their lifelong work and continued until they were in their late eighties.

In 1979, the Amana Furniture and Clock Shop included a replica of a Hahn-designed clock among the limited-edition selections. One of the popular clock models is the Amana Sandstone grandfather clock, which

stands approximately seven feet tall, has hand carving on the crown, and a special movement and dial design that make it unique. The paintings on the moon dial are based on two original oil paintings by local artist Ruth Schmieder, commissioned for this purpose. The manager of the Amana Furniture and Clock Shop in 2005, David Rettig, is the great-great grandson of Friedrich Hahn.

Krauss Furniture is also well known for its selection of grandfather, mantel, and wall clocks.

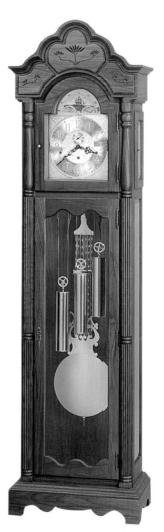

Above: *Mantel clock*

———

Right: *Grandfather clock*

Both are from the Amana Furniture and Clock Shop.

Basketry, Broom Making, Caning, and Carpet Weaving

Christian Metz and the elders were pleased that their new homeland in America enabled the Inspirationists to create a self-sufficient community. Part of this self-sufficiency included making containers, particularly baskets. Each village planted its own fields of cultured willows with top-quality seedlings, many of which were brought from Germany, grown in Ebenezer, and then transferred once again to Iowa.

Basket Making

Basket making is one of the oldest and most common crafts of the world. Relatively few examples of early baskets exist, however, because the materials used to create the baskets do not age well and tend to disintegrate. The few extant examples have been carbon-dated back to around 7000 BC. The craft was probably widespread because baskets served such a variety of needs, from carrying foodstuffs to being incorporated into equipment used for fishing and transporting building materials. Some baskets were woven in open, lightweight patterns; others were woven so tightly that they would hold liquids. Baskets were made in a variety of shapes and from a diversity of materials.

Three basic types of baskets were made and used in the Amanas: splint-oak plaited baskets, coiled baskets, and willow baskets.

Splint-Oak Baskets

The Schaup family lived among the Pennsylvania Germans before locating in Canada around 1798. In the 1840s the family joined the Community of True Inspiration. The Schaups were among the early groups to settle in Iowa and probably were asked to do so at that time because of their skills in making splint-oak baskets, locally called *Schaup Korbe* (Schaup baskets). The family's knowledge of weaving splint-oak baskets may well have been acquired from their former German neighbors in Pennsylvania or possibly from the native Americans as so many

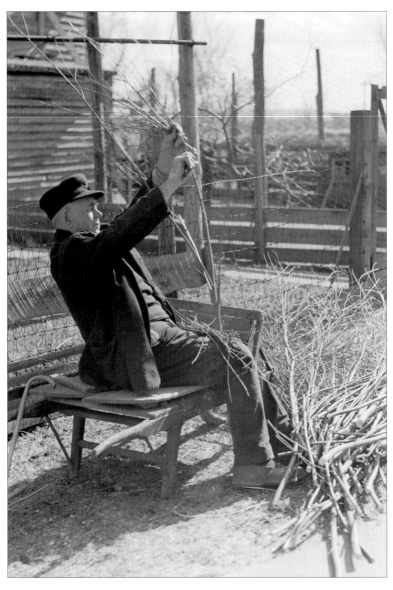

One of the master basket weavers selecting willows for weaving was photographed in 1937 by John Barry.

other newly settled Americans groups had done. During the years preceding The Great Change, the craftsmen made their furniture, brooms, baskets, and other items almost exclusively for the members of the Amana Society. One or two broom makers could be found in every village.

Splint-oak baskets are made of thin, flexible strips of oak that are obtained from lengths of tree trunks cut vertically in half, halved again and again until the splints are thin enough to be flexible. In the final stages some are even shaved to obtain the desirable thinness. The splints are then soaked in water and interwoven using a plain over-one-under-one checkerboard pattern.

The base and sides of baskets are usually woven down sides and across the bottom with thicker material. Weavers using thinner and narrower splints define the base and build the sides of the basket. Heavy knotched handles are added during side-weaving or before rim-lashing. Rim splints are folded over side-weavers and tucked into weaving. Splints that cover the "foldover" are lashed in place using a narrow splint. In some cases, the Schaups painted the finished baskets blue or yellow as a decorative touch.

Most of the splint-oak woven baskets in Amana were used to carry smaller items such as sewing supplies, soap, candles, and even cookies home from the communal kitchens at Christmas. If a basket was used for transporting cheese, the whey in the cheese and the constant cleaning of the splints on the inner sides and bottom bleached the oak splints. Today reed plaited baskets are made in sizes and shapes of the old splint baskets for multipurpose.

Coiled Baskets

Coiled baskets were made of slough grass or rye grass that was cut from the fields as it matured, tied in bundles, and stored and dried until needed. Later it was soaked to make it more pliable. After soaking, bundles, half an inch thick, were tied in place with string from flour sacks so lashing or sewing could be started. The lashing either went into the previous row of coil or loops into the previous row of lashing. New straw was added when needed to keep the coil continuous. Thin splints of wood were used for lashing before the binder cane. The communal bakers

placed the prepared bread dough in baskets of this type and shape, however, the coiled basket construction was such that the baskets had to be repaired more often than the basket makers and bakers liked. Originally the baker tossed a handful of cracked wheat flour on the inner surface of the basket to prevent the dough from sticking before he started to punch down the dough. In time the tinsmiths crafted tin liners to fit the inner arc of the baskets so that the dough could be slid easily out of the baskets and onto the long-handled wooden paddles, or peels, that the bakers used to place the large round loaves into hearth ovens. Thick slices of the crusty bread were served several times a day in the communal kitchens. South Amana baker William F. Zuber (1886–1960) was the last person to make this type of basket in the Amanas.

Amana coiled baskets were primarily made for use in the bakeries and were, by the nature of their materials, increasingly fragile as they aged, so very few examples of these early baskets survive today.

Willow Baskets

Willow baskets have been the most common type of baskets made and used in the Amanas, both in earlier days and today. These woven baskets range in size from small to relatively large containers and are made for many purposes. They are round or oval in shape with or without handles, depending upon the intended use. Villagers of all ages used baskets. The school children received daily knitting lessons and while in the elementary grades each child had a basket for storing his or her needles and yarns. Women carried food home from the communal kitchens in baskets if someone was ill. Small baskets were made to cradle newborns, while large baskets could be found in the gardens when harvesting vegetables, collecting grapes from the trellises for wine making, or for harvesting field crops. Those made for apple picking, called "picker baskets," were unique in that they had two willow handles woven side by side along the upper rim so that the weight of the basket could be suspended by the handles, and the basket could be held in place at the picker's waistline to free both hands for more efficient picking. Some of the laundry baskets had hinged lids. Baskets used for gathering potatoes or onions usually had iron handles.

Baskets played a vital part in daily life. My grandfather Possehl continued using the big, round, heavy Amana willow woven baskets even after he left the Amanas and moved to his own farm.

The willow, or osier, is a fast-growing plant that responds well to careful husbandry and skillful cultivation. The flexibility and durability of willow makes it an ideal plant for the necessary twisting and turning of the rods by nimble fingers. The cutting and sorting of the willow is usually done in late fall after the leaves fall. Before using, withy are sometimes stripped of the outer bark, producing a white/cream color. In Amana, basket makers boiled willow shoots in the dye kettles at the woolen mills to remove the bark, giving the resulting peeled willow a tan color. The basket maker began his work by selecting thick willows to form a base created by slitting one set of willows so that the other set could be slipped inside to form a cross. He then wove the base by twining two willows between the willow frame and placed the completed base over a spike sticking up from the weaving bench.

These steps were followed by the weaver inserting willows into the sides of the base, bending them, and fastening the tops together, producing something that looked very much like a bird cage. Next, the basket maker wove thinner willows between the upright willow to form the walls of the basket. In Amana, the standard weave was to begin with several rows of a four-rod wale, then to use the simpler French randing to build the height of the basket, before returning to the four-rod wale near the top. Homestead basket makers started their baskets with French randing, then used the four-rod wale later in the process, making it easy to identify the baskets of the Homestead shop from the other Amana baskets.

To extend a basket's life, an additional replaceable rim was added to protect the bottom of the basket. This was a technique the Inspirationists retained from the days of living in Germany. The rim protected the base from wear and, when the rim was worn, it could be removed and replaced. If a basket needed to be repaired or replaced, an individual would simply ask for one from the basket maker.

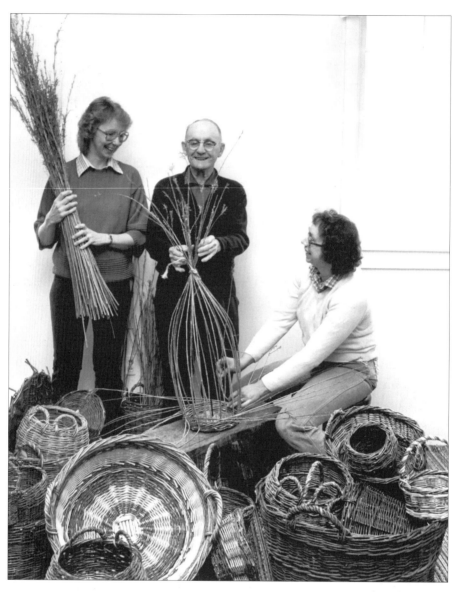

Kathy Kellenberger, left, is holding willow branches for a basket. Philip Dickel (1900–1981) is standing while Joanna Schanz is seated in front of his basket bench. In the foreground is his wife's large laundry basket of peeled willow. Other baskets are an apple picker, bushel garden baskets, a small sewing basket, and a one-handle garden basket.

Every Amana basket was made for a purpose and not just as an accessory for a table top or book shelf. Sometimes basket weavers used peeled and unpeeled willows in combination to create designs. These designs enhanced the natural beauty achieved through the materials used, the textures created, and the overall beauty and neatness created by the skilled and agile hands of the artisans. The aim of each and every basket maker was to make the baskets perfect. It took about a day to make a basket of average size. Among the communal-era basket makers were: Martin Trautmann (1816–1884) and Ludwig Dietrich (1851–1937) of Main Amana; Philip Kippenhan (1838–1913) and Richard Seifert, Jr. (1895–1980) of Homestead; Johann Hug (1847–1939) of High Amana; Alvin Werner (1869–1931) and Otto Bahndorf (1904–1987) of East Amana; Friedrich Weinhold (1801–1898), Carl F. Mueller (1836–1914), August Rettig III (1893–1959), and Phillip Dickel (1899–1981) of Middle Amana; David Werner (1828–1894) and Gustav Schaedlich (1859–1935) of West Amana; and Jakob Wickersheim (1815–1877) of South Amana.

Following the economic change in 1932 and the advent of capitalism, markets for the new style of entrepreneurship, such as basketry, broom making, and caning, could not provide the artisans an adequate livelihood. Consequently, the techniques involved with these crafts gradually vanished within the Society.

In the 1970s, Joanna and Norman Schanz ably stepped in to revive these arts. Philip Dickel, one of the few remaining basket makers, taught Joanna Schanz the steps involved in basketmaking, from growing the willow to making the completed baskets. With her enthusiasm, tutelage, and hard work, Joanna, along with Kathy Kellenberger, Laura Kleinmeyer, and others, have revitalized this craft, which probably would have otherwise vanished. These modern basketmakers have expanded their craft from the use of traditional materials to a variety of new materials, including grape and other kinds of vines, twigs, and bittersweet. They have also woven new types of baskets and made variations of the old Amana styles.

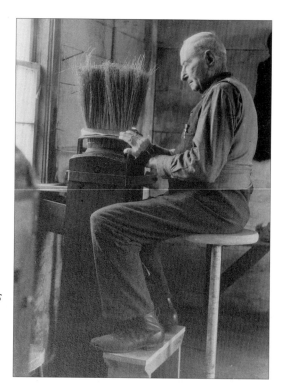

William Noé photographed one of the last broom makers in the historic Amanas.

Amana Brooms

Among the useful items made by Amana craftsmen for use in the villages were brooms. Brooms were a welcomed refinement of the primitive floor sweepers of an earlier day that were used in Europe and composed of a bundle of sticks tied together and fastened to a long handle. Typically, each village had its own broom maker, usually an older man, who produced brooms during the winter months. Among the Amana broom makers were August Reissner (1813–1893) and Heinrich Haas (1874–1948) of Amana; Herman Puegner (1847–1917) of High Amana; Heinrich Specht (1882–1919) of West Amana; and Joseph Peteler (1818–1906) of Homestead and, later, East Amana.

Broom corn, a member of the sorghum family, was grown and harvested in the Amanas. As the crop matured, workers bent over the top sections of the stiff branching stalks, which were ten to fifteen inches tall, and allowed them to dry. Later, the tops would be cut, seeds removed, and the straw readied for broom making. The seeds were saved for planting the following season.

The dry straw was tied together in bundles, soaked in water to make them more pliable, and attached to a wooden handle by means of a wire wrapped around the top as needed to create the desired ultimate size. Broom handles were clamped in a broom winding machine and wire attached to the handle. Broom straw was placed on the handle under wire as the broom maker operated the "kicker" winding machine by his feet. In the 1800s twine was used as the binding medium; today a sturdy commercial cord is used. The last step is trimming the ends of the straw, providing a clean-cut look.

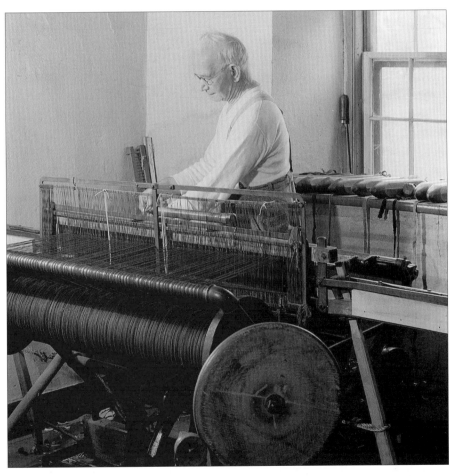

From a series of photographs by John Barry of crafts workers in the Amanas, this image shows, in 1937, one of the last of the communal era carpet weavers.

Amana broom makers also made a variety of smaller brushes and whiskbrooms with short handles, used to brush clothing, sweep crumbs off the kitchen hearths and tables, and other uses. A particularly unusual type of broom still made in Amana is known as the sideliner whiskbroom, a small one-sided brush.

Philip Griess (1888–1977) of West Amana was the last active broom maker from communal-era Amana. A blind artisan, he proudly made many, many brooms until the 1960s. Later, he passed his skills and equipment on to Norman and Joanna Schanz, who opened a broom and basket shop near their home in West Amana in 1972. Through the years, broom makers in this shop have demonstrated this unique skill to thousands of visitors and school children.

Floor Covering

In the early days, floors were laid with six-inch wide pine planks that were scrubbed regularly with soap and water. Fourteen years after the first Amana settlements were made, the elders appointed men to be carpet weavers. As the supply of carpeting increased, floors were covered with colorful widths of woven rag carpeting made from wool or cotton scraps left over from the woolen mill, calico print mill, or worn suits and shirts, old sheets, towels and tablecloths. Most scraps were dyed blue, black, and brown and a few dyed red or green at one of the Society's two woolen mills. During an afternoon "carpet bee," to which neighborhood women would be invited, or free evening hours at home, many Society mothers and grandmothers would cut the scraps into one-inch-wide pieces, sew the ends together to produce a continuous ribbon, and roll the sewed strips into balls to be used as the weft or filler for the carpets. Generally, it took approximately forty-eight pounds of rags to produce enough carpet strips to cover a typical 15 x 15 foot Amana room. The early hand looms were large and the shuttles had to be shot through the shed by hand and the weft tightly tamped manually into place.

Among the communal-era carpet weavers were Heinrich Muth (1820–1886) of Main Amana; Friedrich Rupprecht (1817–1891) of Middle Amana; Emil Schaufuss (1855–1946) of High Amana; Ernst Hugo Leichsenring (1867–1941) of South Amana; Andreas Pfeffer (1823–1905)

and Louis Hess (1857–1941) of East Amana; and Karl Adolph Kampf (1824–1910) and Oskar Tautenhan (1862–1932) of Homestead.

Around the turn of the century, smaller semi-automatic looms became available, and the Society purchased the first such looms from the Newcomb Loom Company of Davenport, Iowa, in 1907. The semi-automatic looms featured a mechanism that shot the shuttle through the warp automatically, making the weaving process much easier. Older men who had previous experience as weavers in one of the mills were often selected by the elders for this wintertime duty. They would make 36-inch-wide carpeting for the 15 x 15 foot rooms and 22-inch wide stair runners, with between seven and nine warp threads per inch. The 36-inch strips were made in that width so that five strips would completely cover the floor. The strips were sewn together and tacked to the plank floor all around the perimeter of the room. A layer of paper was placed directly over the flooring and under the carpet. A regular and thorough spring and fall house cleaning required the removal of the many black-headed, long shank tacks so the carpet could be lifted and hung outdoors on the clothes line and beaten free of dust and dirt. If a strip became worn, it could be easily replaced. The striped carpets and the warm tones of beautiful woods against the calcimine blue walls melded together to provide an aura of warmth and friendliness.

At the time of The Great Change and later, many women of surrounding communities became attracted to the Amana rag carpets and started preparing their own balls of cotton or wool strips of fabric to take to the Amanas to be woven into carpets by an Amana weaver.

The craft of weaving rag carpets is still carried on by a select number of weavers who learned the art of weaving from their fathers and grandfathers. Carpet weaving continued in the Amanas into the present through the efforts of individuals such as George Berger, sisters Clara Leichsenring Mittelbach (1897–1992) and Elsie Leichsenring Berger (1902–2002), Verona Schinnerling (1905–2001), and Dorothy Trumpold (born 1912), who was the recipient of a prestigious National Heritage Folk Art Award from the National Endowment for the Arts in 2001, one of only thirteen people so honored that year.

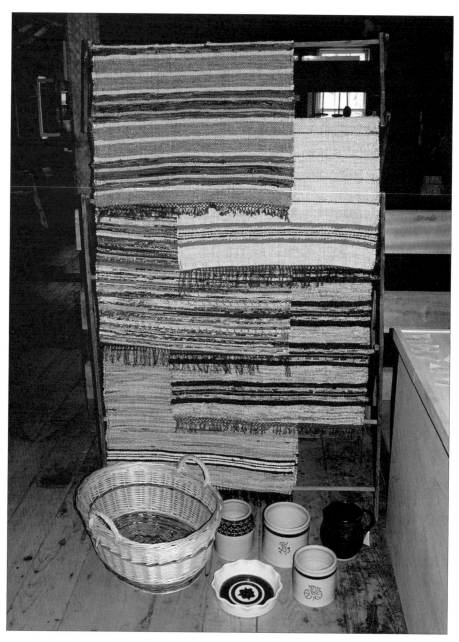

The Amana Arts Guild in the former High Amana Meetinghouse attic offers handwoven rugs by George Berger of South Amana. The basket shown is by Joanna Schanz, and crocks crafted in the communal style are by Gordon Kellenberger. The Guild identifies master crafts people.

Coopers, Tinsmiths, Blacksmiths, and other Craftsmen

The Amanas had many craftsmen but not all skills were represented in every village. Because of a limited need for certain items, craftsmen such as tinsmiths were located only in the larger villages, where they produced the items needed by all the Amana communities. The shops were strategically placed so that the workmen could help one another with whatever supplies and labor that were needed. For example, the blacksmith could sometimes be found in a nearby shop helping to get the farm equipment ready for the planting season rather than forging iron. At times these skills would overlap; other times there would be voids. They all worked together in a helpful relationship and as directed by the elders. During the summer and harvest time, many craftsmen helped with farm labor, as needed.

The U.S. Census of 1870 lists the occupations of the male population of Amana Township as consisting mostly of farmers, carpenters, millwrights, masons, coopers, locksmiths, blacksmiths, and wagon makers. By 1890 the villages had become more established and needs changed. The composition of the male workforce also changed with the addition of many other skilled workers such as millers, painters, tailors, saddlers, harness makers, butchers, bakers, railroad agents, farm laborers, and mail carriers.

The Cooper

The cooper was the craftsman who made wooden casks, kegs, and tubs. Casks were bulging barrel-shaped containers that were made of wooden staves tightly held together by hoops. Their primary purpose was to catch rain water or store the popular wine and beer made from the plentiful supplies of red and purple wine grapes and the bushels of barley harvested for beer making. An elder in charge of the wine dispensation within a village handed out cards that were punched each time a member received

his or her quota. Adult males were annually provided approximately twelve gallons of wine and adult females six gallons. One can only imagine the number of casks required, considering the total population numbered 1,813 in 1881. Beer kegs were needed from the time the early settlers arrived until the 1880s, when Iowa law prohibited the brewing of beer without a financial payment to the government. The Inspirationists did not want to pay this money to the government, so they discontinued beer production until more recent years. During the period that beer was made, it was stored in casks similar to the wine casks.

The water buckets made by the coopers were used by the farm workers to carry water to the fields. They would be hidden in the weeds to keep the water cool. The coopers are also credited with creating many other items such as bath tubs, troughs for watering and feeding livestock, presses for rhubarb, and the like. The needs were sufficiently great that each village, except High Amana, had its own cooper shop. A popular wedding gift for newlyweds was a wooden tub crafted by the cooper. As inexpensive machine-made containers became available from outside the community, the demand for the cooper's work waned, and the last cooper shops in the Amanas closed at the time of the 1932 reorganization.

The coopers made little wooden vessels such as this one above used for footwashing during communion services.

The Tinsmith

Tinsmiths received their work assignments from the elders just as other craftsmen were assigned their work duties. Their primary duty was to create the metal utensils and equipment used in the kitchens, meat shops, bakeries, and wash houses and repair them when necessary. Every kitchen needed the usual kettles large and small, lids and ladles, coffee pots, sieves, strainers, funnels, colanders, potato ricers, graters, tea kettles, cream and milk pans, all for preparing and serving three hearty meals per day for large numbers of people. In addition, tinsmiths made special items such as star-shaped cake pans for the special-occasion cakes used at weddings.

The Easter bunny would rely on the tinsmith to have plenty of 12-inch rabbit-shaped cookie cutters ready for the kitchen helpers to make cookies for the Easter baskets in the spring. With over fifty communal kitchens in the Amana villages, one wonders how many rabbit cutters were made. All the kitchens were reportedly well equipped with the necessary tinware.

A father made this replica of a communal kitchen including the tinware for his three daughters. The Homestead Store Museum displays the kitchen doll house.

In addition to small pieces of equipment, each kitchen had a long, low brick stove with an iron stove top. At the back of the cooking surface and attached to the wall was a tall, wide, shiny sheet of tin that served as a protective shield for the wall. A few hooks were conveniently placed along the side for spoons and ladles. The tinsmiths were responsible for making, installing, and maintaining these large shields of tin.

The meat shops required a variety of different-sized containers for a number of the processing steps, from butchering to sausage making. Every thirsty school child was familiar with the traditional bucket and dipper near the water pump. The tinsmiths made liners for holding the yeast dough in the coiled baskets while the bread was rising. Tall tin milk cans with lids were used for transporting milk from the dairy barns to the kitchens. Every family had a bathtub, either a tin one made by the tinsmith or a wooden one made by the cooper. The tinsmith was the person who made the tinder boxes that contained the flint, steel, fabric, and wood chips necessary for creating a flame for lighting candles. He also made the street lanterns, down spouts and stove pipes, and was responsible for roofs on farm buildings. He was a busy man.

The early tinsmiths reportedly transported some of their equipment from Germany to Ebenezer and later on to tin shops located in Homestead, East Amana (until 1865), and Main Amana. As Society membership expanded rapidly, additional equipment and supplies were purchased from a company in Chicago and shipped to Amana. Each shop was outfitted with a sizable metal container for holding coals, a brazier for melting the solder and heating the soldering irons. Numerous smaller manual items included tools used in cutting and creating patterns and shaping alloys of tin, steel, and copper. Among the Amana tinsmiths were Johann Georg Henkler (1826–1874), Peter Wuest (1837–1893) and his grandson, Peter Fels (1874–1948), all of Homestead; and Heinrich Erzinger (1847–1893) and his nephew J. George Erzinger (1872–1960) of Main Amana. During a brief sojourn outside the Amanas, Heinrich Erzinger authored and published a book of tinsmithing patterns and techniques.

At the time of The Great Change in 1932, the communal kitchens closed, resulting in a decreased demand for tin-crafted utensils. Products to replace the tin ones were becoming available on the commercial market. The last tin shop in the Amanas closed in 1941. The craft was nearly lost

in the Amanas until revised in the 1980s by William Metz (born 1933) of Middle Amana, who has been exceedingly creative in his work. He conducts classes in lantern making and tinsmithing at certain times of the year for the Amana Arts Guild. He also periodically demonstrates the techniques he has perfected at fairs and crafts shows across the Midwest. Metz is especially well known for the over two hundred street lanterns he has produced for Amana residents, as well as for the intricate star-shaped cake molds he recreates.

Pewter and Copperware

An early, and today virtually forgotten craft in both Ebenezer and Amana, was the production of copper and pewter ware. The copper was largely the product of the Amana tinsmiths who produced small quantities of kettles and ladles from the material. Pewter was produced only in the earliest days of the community, using molds brought from Germany in which such items as plates and oil lamps could be cast. This production never seems to have been widespread, although pewter items were in use in some communal kitchens until around 1900 when they were replaced with newer materials. Examples of copper and pewter ware are in the Amana Heritage Museum.

Pottery

During the years in Ebenezer, the Society operated a small pottery shop that produced pitchers, containers, flower pots, a small number of dishes, and other articles. The clay at Ebenezer was red, lending a distinctive color to earthenware produced there, and was often covered by a brown or black glaze. Upon his arrival in Amana, Ebenezer potter Johann Fritz (1828–1903) found that the new clay warped easily and was unsuitable for pottery. Although he did produce a number of decorated flower pots for community use, Fritz soon turned to other pursuits. The community purchased most of its pottery from outside firms.

Since the 1970s, several potters have practiced their craft in the Amanas. The Amana Society operated a small pottery studio in the basement of the South Amana General Store for approximately ten years following 1975. Local artist Gordon Kellenberger has produced pottery

that was inspired by the original Ebenezer designs, as well as a variety of cups, bowls, and other containers in more contemporary styles. His wife, DeAnna Kellenberger, is well-known for her painted tiles and other decorative clay work.

Blacksmiths, Fabricators, and Machinists

Every Amana village had a blacksmith shop and Middle and Main Amana had machine shops in connection with the woolen mills. The iron workers heated iron over coals in a brazier, or forge, and then shaped the hot iron into utilitarian objects such as horseshoes, foot scrapers for cleaning muddy shoes, door latches, hangers for drying seed corn, hinges, metal parts for wagons, and hooks for every piece of equipment that was to be hung, whether in the barn or in a communal kitchen. Amana blacksmiths sharpened plows, shovels, and hoes and, in 1905, shod over 273 horses. Machinists at the two Society woolen mills were responsible for fabricating, assembling, and repairing the parts for machinery.

These artisans also often possessed special engineering skills, such as the ability to construct the dredges for the mill race, machinery for the numerous mills, and construct the large warming ovens used in the communal kitchens. At the other end of the spectrum, they made Amana crochet hooks. West Amana blacksmith Carl Graesser (1893–1973) was known for his fish spears and also for the fine paring knives that he produced from recycled saw blades, as was blacksmith Carl Ackerman (1901–1961), the last Amana-born blacksmith. He produced items such as a decorative umbrella stand as a gift for his wife.

Most of the work done by Amana metalsmiths was practical and without ornamentation. However, blacksmith Henry Schuhmacher (1894–1958) of Amana was known for the decorative iron railings he made for porches and stairs. Not all metal items used in the villages were produced there. The elders directed the efforts and energies of their available manpower to those areas where they felt it would be used most efficiently. They purchased other items from outside.

One example was the cast-iron "Wild Rose" heating stove found in most apartments to stave off the winter cold as there were no fireplaces or central heating. While the last communal-era blacksmith shop in the Amanas closed in 1961, the craft has been revived in recent years.

Roger Quaintance operated a forge in the former Amana machine shop that specialized in decorative items. Upon his retirement, a group of younger blacksmiths took over the shop and, today, continue the tradition of Amana metal work. In 2003, blacksmith Gerald Rieskamp leased the West Amana blacksmith shop from the Amana Arts Guild, and has also begun to produce hand-forged items. For many years, the Arts Guild has offered winter blacksmithing classes at the old West Amana forge.

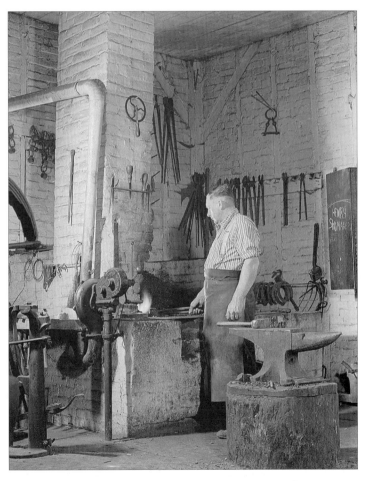

The Smithy with Henry Schumacher
Five years after The Great Change the Amanas still had a blacksmith shop, as documented by John Barry.

Other Craftsmen

Many other craftsmen who did not fit into the previous categories were scattered throughout the villages in varying numbers. Workers such as printers and book-binders, watch and clock repairmen, shoemakers, locksmiths, harness makers, wheelwrights, and wagonmakers are among these groups. For decades the Society operated a small soap factory in Main Amana to produce soap for use in community wash houses, kitchens, and shops.

The printer and bookbinder were both centrally located in Middle Amana, where books such as hymnals, school textbooks, religious materials, invoices, and forms for systematizing business records were printed. Still in operation, the Print Shop continues to publish the local *Amana Society Bulletin.*

Wagonmakers and wheelwrights were responsible for making strong wagons with spoke wheels. Sturdily made oxen-drawn vehicles often had to cross swollen streams or travel rough, muddy paths, transporting people and agricultural products as well as industrial products from raw materials to manufactured goods. Wheels of all sizes and purposes were needed, including wheels for mills, wagons, and children's scooters.

The large herds of livestock provided an ample supply of hides for various purposes. For many years in both Ebenezer and High Amana, the Society operated a leather tannery. A large quantity of the leather produced was used by village harness makers and cobblers in their crafts. The village shoemakers originally produced leather shoes from scratch. By the turn of the century, the Society purchased shoes from outside the community and the cobbler was then in charge of keeping them in good repair. Some wooden shoes for use in wash houses were made. The last Amana shoe shop, located in Middle Amana, was operated by Carl Herger, Sr. (1883–1972) until 1950.

Brick makers who worked in the brickyards, millers in the feed mills, brewers in the brewery, locksmiths in the lock shops, harness makers in the harness shops, tailors and watchmakers in their homes, and the assortment of other workers all contributed in their respective ways to the betterment and success of the Community of True Inspiration.

Art and Artists in the Amanas

The Inspirationists discouraged the visual arts because, to them, painted pictures, sculpture, and photographs represented a breech of the second commandment forbidding graven images. As a result, the visual arts did not flourish in the Amanas until the turn of the twentieth century.

This is not to suggest, however, that visual and graphic arts were completely absent from the community in earlier days. Indeed, one of the leading elders of the Ebenezer Society, Joseph Prestele, achieved a national reputation for botanical illustrations that he produced for the United States government; the elders approved both because of Prestele's skills and because of the income generated for the Society.

Lithographer Joseph Prestele and His Sons

Joseph Prestele (1796–1867) was born in a most picturesque part of the world, Bavaria, Germany. His little village of Jettingen was in the midst of an area blessed with gently rolling hills, meadowlands, forests and woodlands, and mountain streams of clear, blue water. It was not far from the Danube River. The climate and topography were especially suitable for cultivating plants. At one end of his small village was a church with a tall, awe-inspiring steeple; at the other end was an imposing castle surrounded by well-manicured gardens and orchards. Prestele's father was reportedly a caretaker at the castle. The elder Prestele's devotion to the daily care of the wide variety of plants led to his son also developing a strong interest in botanicals.

As the young Prestele matured, he studied botany, worked in a nursery, and acquired some training in painting and drawing. In the early 1800s he moved to Munich. His interest and outstanding work there as a horticulturist attracted the attention of the King of Bavaria, who gave him financial support. Prestele soon found that he was not only interested in growing plants but also in reproducing their forms and color on paper.

At this time lithography, the process of drawing an image on stone, treating it with chemicals, then printing the resulting plate, was a new and impressive artistic technique for pictorial representation. Prestele became well known regionally for his skills in creating beautiful realistic prints of fruits and flowers using the innovative method of reproducing colored images on stone surfaces in such a way that inks could be absorbed or resisted.

Prestele had been reared as a Catholic, but as a young man began questioning his religious beliefs. In 1835 Christian Metz encouraged him to move to Engelthal, one of the estates leased by the Inspirationists, and join the Community of True Inspiration. He tried to continue producing his lithographs in his new surroundings but encountered difficulty in doing so while living such a religiously restricted life. In 1843, he and his family were among the first believers to travel to the new settlement at Ebenezer. The elders continued to ignore his artistic abilities, but his background in horticulture led to their assigning him the task of planning and planting apple orchards. The work was too strenuous, however, and caused him to have major health problems.

As a more sedentary individual, Prestele then conceived the idea of producing lithographs to sell outside the Ebenezer community and giving the income to the Society. He needed an effective marketing tool. He made contact with former European colleagues and, through them, including Harvard professor Asa Gray, restarted his beloved art. The path was not easy, but he eventually sold some of his lithographs, had some published, and eventually produced many for the U.S. government.

The subsequent move of the Inspirationists from Ebenezer to Iowa caused additional problems for him at a time when his kind of artistic endeavor was being challenged by new and less expensive techniques developed elsewhere in the country. Although he had outstanding drawing skills, his inability to obtain supplies and to market his work successfully became challenging in Iowa, which was more remote than Ebenezer. Prestele was basically an artist and horticulturist, not a marketer or promoter. In Amana, Prestele planted a large orchard and garden, which he tended until his death in 1867.

Prestele's Three Sons

Joseph Prestele had three sons: Joseph, Jr. (born 1824), Gottlieb (1827–1892), and William Henry (1838–1894), each of whom followed some aspects of their father's interests and skills in horticulture and lithography. The eldest son, Joseph, Jr., moved with his family to Ebenezer but left the community as a young man. Only periodically did he contact his family, causing much grief to his parents. The only professional data of record is that he worked a short time for a lithographer in New York City. Several decades later he joined his youngest brother, William Henry, in working for a nursery in Illinois as a painter of fruit and flowers. This employment lasted only a few short years, after which he disappeared from the record.

The second son, Gottlieb, shared his father's interests, particularly in drawing flowers. He worked alongside his father as an assistant and probably did much of the hand coloring during the years in Ebenezer. He moved with his family to Amana.

By the 1870s, sales of Gottlieb's work waned. To spur his slow sales, he prepared and printed an illustrated catalog of his work. This catalog was later revised, but sales continued to decline. In 1875 he was assigned work in the Amana calico print works, where he designed patterns. He continued painting for his own enjoyment and occasionally presented friends with gifts of his work.

The third son, Wilhelm Heinrich, or William Henry, as he was called in America, was a highly spirited young man. At the time his family moved to Amana with the Inspirationists, William left the Society, went to New York City, and joined the military, a practice not in keeping with the beliefs of the Inspirationists. After the Civil War, William was hired to make a set of plates for a nursery in Bloomington, Illinois, for an enterprising nurseryman who had built the second-largest company of its kind in the country. His brother Joseph, Jr. joined him for a period of time.

Both brothers left the nursery company in 1872. William Henry became self-employed in Bloomington. Later he moved to Coralville, Iowa, a suburb of Iowa City, twenty miles from Amana, and continued his work. He made more nursery plates and prepared various types of commercial materials, which sold well for many years.

In 1887, at age forty-nine, William Henry was appointed "First Artist" in the newly created Pomological Division of the Department of Agriculture in Washington, D.C., and became prominent. His primary work was to make exacting water color and ink drawings of the surfaces, interiors, seeds, stems, and leaves of fruit. The work was detailed and had to be precise. William Henry Prestele died in 1894 and, as a Civil War veteran, was buried in Arlington National Cemetery.

The Work of Prestele Still Cherished

The lithographs of Joseph Prestele and his sons are among the notable arts of the community that have persevered through the years. The artistic contributions of the Presteles received scant mention in the church histories even though they have had major recognition and lasting importance outside of the community. There have been several exhibitions of their prints and a book, *Drawn from Nature*, by Charles van Ravanswaay, published by the Smithsonian. Many of the prints have been framed in dark walnut frames and hung on blue calcimine walls in Amana homes. Some families are fortunate in having original prints.

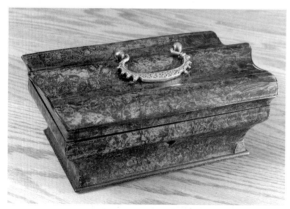

(Courtesy Dan Berger)

*A beautiful box handcrafted of walnut burl overlay
by Joseph Prestele features a print of a rose inside.*

The Arts Gain Importance

For decades many skilled artisans of this highly disciplined Society focused on making only the basic utilitarian items that they needed, such as baskets and brooms, furniture, rag carpets, barrels, and buckets. These products made daily lives a little more comfortable, as the work and daily routines were subordinated to the whole-hearted dedication and adherence to religious beliefs. Perhaps it was because of the austere and rigid lifestyle for so many years that Society men and women began to search for new kinds of freedom and ways to express themselves artistically.

Shortly after the turn of the century, the Society's younger members became aware of the freedoms of their counterparts in nearby communities, and exerted pressure on the elders for fewer restrictions. They were anxious to extend and expand their horizons. Gradually the elders relaxed some of the stricter regulations, and the old ways were replaced with more acceptable twentieth-century viewpoints. As direction changed, the arts gained in importance. Artists started to express their visual flair and emotions by using a variety of media and tools.

Photographers and Their Photographs

In the 1870s the leaders of the Amana Society discouraged members from taking photographs. The restrictions against photography carried over into the early twentieth century although they were gradually relaxed, but not without reservation and apprehension. Change did not come quickly in Amana. In light of the previous prohibitions, many of the early photographers photographed outside: street scenes, a wash house, or a pine forest. As courage and confidence were built, more and more images of individuals, families, and their activities were made.

The Photographers from Within

Inspirationists from a variety of professional backgrounds are among some of the well-known early Amana photographers. Among these were Jacob Selzer (1888–1917), Homestead saddle maker; F. William Miller (1876–1952), Main Amana pharmacist; High Amana store keeper William Foerstner (1881–1974); Frederich Oehl, Sr. (1866–1946), salesman for the

Main Amana general store; Homestead postmaster John L. Eichacker (1882–1935); Middle Amana physician Dr. Christian Herrmann (1890–1970); Main Amana teachers Peter Stuck (1890–1979) and Ludwig Unglenk, Sr. (1869–1941); and Adolf B. Siegrist (born 1856), a farm worker who left Amana in 1905.

While most of the photographers were men, Henrietta Geiger Selzer (1892–1968), wife of Jacob, took up photography after her husband's death and produced charming portraits of her family and friends. These individuals and many others like them started enjoying their newly found avocations and used their time and talents toward making what, unbeknownst to them, would become a historical record.

Several members of the Noé family made major contributions in photography and art. Father John, Sr., even though he was the son of one of the leading elders, developed an interest in photography early in the 1900s. His sons, William (1898–1978) and John, Jr. (1900–1954), inherited their father's interest in the arts, as well as those of their maternal grandfather, Friedrich Hahn, and each man contributed in his respective way.

William Noé became an especially prolific photographer within the Society. His interest began as an avocation in the late 1920s and continued for some thirty years, well after the Society changed from to a capitalistic system. He developed a reputation for being very methodical and analytical in his selection of subject matter as well as innovative in his use of special techniques. A sense of drama can be seen in his use of light and dark values.

The images in the photographic work of William Noé cover most phases of life in Amana: cultural, religious, and economic. He photographed children at work and play and broom makers, basket makers, and cabinetmakers in their craft shops. He did much of the advertising photography for the Society as well as for individual businesses in marketing their products after the shift to capitalism. Brother John, Jr., shared an interest in photography, but eventually the use of a brush and palette attracted him more than a camera.

In the 1930s, two brothers in another family, Rudy (1907–1996) and Paul Kellenberger (1909–2003), developed an interest in photography.

Their photography led them in decidedly different directions, however. Rudy concentrated on the agricultural phases of community life. Paul, on the other hand, was more concerned with the lifestyle of old Amana until service in World War II took him to the Pacific arena. Wartime experience expanded his horizons and his photography. The new orientation led him to academia, which helped shape a different course for the future, a career in the insurance industry. Paul was the youngest member of the Committee of Forty-Seven that planned the Amana reorganization in 1932. He continued to take pictures until shortly before his death in 2003.

Photographers from the Outside

Bertha Horack Shambaugh (1871–1953), the wife of Benjamin F. Shambaugh, head of the State Historical Society of Iowa and a popular university professor in nearby Iowa City, is credited with breaking many of the negative attitudes against photography. As a young woman, Shambaugh often visited the Amanas and became a trusted friend to many of its members. This trust paved the way for her to be able to start taking photographs despite the religious policy against it. Shambaugh was academically oriented and independent in her thinking.

Shambaugh used glass plate negatives, as did most of the early Amana photographers who followed. This technology involved much trial and error with adjusting bellows, estimating the time exposure and f-stops, and skill in focusing subjects under the traditional black cloth. Developing was done in home darkrooms. Her historic photographs ranged from documenting the daily personal activities of the people to their man-made and natural environments. One day she would photograph a child learning to knit; the next trip she would create images of the exterior of a meetinghouse or children at play. She was constantly concerned with good composition and the value of shadows and light. Her superb pictorial documentation, as well as her published works about the early days of Amana, are invaluable records of the past. Shambaugh helped open many doors for making visual images an acceptable art form to photographers within the Society and for others wishing to enter.

Another outside photographer who today is continuing the outstanding work of Shambaugh is Joan Liffring-Zug Bourret (1929__) of Iowa City. She began her photographic career in the 1940s while attending the University of Iowa. Like Shambaugh, Bourret enjoys many personal ties to the people of the villages. Her son David's wife, Carol Roemig Heusinkveld, is a direct descendant of the original settlers, and they live in Amana. Their sons are confirmed members of the Community of True Inspiration. One son, Jordan Heusinkveld, who was killed at age 19 in a car accident, rests in a simple wooden coffin with his grave marked by the traditional plain Amana tombstone. Jordan's grave is close to that of his great-grandmother, Frieda Schmieder Oehl, who died a year later. Joan's color and black and white photographs are in this book and in her book *The Amanas A Photographic Journey 1959–1999*.

Numerous other professional photographers traveled to the Amanas from nearby communities. Most had heard just enough about the seven villages to pique their curiosity about this unique setting where the people dressed differently. Among these visitors was Frederick W. Kent (1894–1984) of Iowa City, a long-time University of Iowa photographer. In addition to his extensive collection of university personalities, events, and campus scenes, he skillfully captured the stories of the lives and homes of many of the Amana Society over a period of years. Others include John H. Richmond (1862–1916), who signed his work "J. Rich," and John Barry (1905–1988) of Cedar Rapids, Iowa. Thomas Teakle (1878–1969) of Iowa City, Jacob F. Specht and Hattie Marble of Marengo also photographed the Amanas. In the early 1940s, noted photographer Dorothea Lange (1895–1965) of California spent two weeks in the Amanas as part of a large project photographing American religious communities.

Amateur Photographers from the Outside

In addition to local Amana photographers and the nearby professionals, there were many amateur photographers among the traveling salespeople and curious visitors. Outsiders would often stop for lunch or an overnight stay. Some carried cameras. During a casual conversation it was not unusual for someone to ask, "May we take pictures inside the meetinghouses?"

or, "Are the lilies on the Lily Lake in bloom now? We'd like to take a picture of them."

Other amateurs from nearby Marengo or Cedar Rapids would drive to Amana for a Sunday ride in their newly acquired Model "T" Fords. In time the sightseers became so numerous that the members of the Society installed "bumper strips," or raised areas on the roadways to discourage the intrusion of some of the traffic. Many Linn, Johnson, or Iowa County family albums have a photograph of an Amana man walking to church in his Amana-tailored black suit without lapels, or images of rows of houses with grapevines growing on the trellises. By the time of The Great Change in 1932, many Amana homes had albums resting atop hand-crocheted doilies gracing the walnut tabletops.

The Painters and Their Paintings

The first exhibit of paintings of Amana artists took place in 1932, some seventy-five years after the Inspirationists arrived in Iowa. The exhibit was held at the Homestead Hotel under the auspices of the Homestead Welfare Club, with assistance from an outsider, Grant Wood (1891–1942). Wood was a regionalist painter from Cedar Rapids who became attached to the Amanas. This close affiliation may be attributed to his rural background and Quaker heritage. During his numerous visits to the Amanas, Wood made oil sketches of local scenes, including landscapes of the surrounding countryside, some of which later formed the basis of one of his major paintings, *Young Corn*. His best-known work is the popular iconographic painting *American Gothic*.

One of his acquaintances, Carl Flick (1904–1976), a young clerk in the general store in West Amana, suffered a temporary facial paralysis due to hunting in the cold and started painting while confined indoors during his recovery. He needed information and guidance about selecting tools and materials, and techniques. He contacted Grant Wood, who became his mentor, took him on sketching excursions, and promoted his work. They painted side-by-side.

Flick became a gifted oil painter. The subjects of many of his early paintings came from pictures on calendars. Wood encouraged him to expand his vision and "look" more at his environment. Wood's influence

can be seen in some stylization, such as the round forms for tree tops often seen in Wood's paintings. Flick also began to strengthen his work with improved use of color and better use of light. Flick's best-known paintings include *Amana Interior* and *Amana Funeral*, the latter depicting a horse-drawn funeral procession. His work has been exhibited nationwide. Wood's relationship with the Amana people continued to grow, as did his artistic influence there. His family visited often. In 1932, a fire nearly destroyed the Wood family's Cedar Rapids studio home at 5 Turner Alley, now an attraction of the Cedar Rapids Museum of Art. The Amana people responded with many acts of kindness and supplies of garden produce for the Wood family.

In the 1940s the oil paintings of Amana businessman John Noé, Jr. (1900–1954) began attracting wide attention. Noé started painting as an avocation while in his early forties, and as he progressed was encouraged by Carl Flick and by Cedar Rapids artist and art professor Marvin Cone. During the relatively short time he painted, he completed more than 200 canvasses of Amana and Iowa scenes and landscapes. One of the most famous owners of a Noé painting was Dwight Eisenhower, who hung his Amana painting in his home in Gettysburg, Pennsylvania. Noé's prolific work has been described as having a serene quality executed in bright, yet well-modulated greyed hues, and has been collected from the east to west coasts.

During the 1930s, two other young Amana men were influenced by Grant Wood. Both John H. Eichacker (1910–1945) of Homestead, who later designed the Amana Society logo, and George Schoenfelder (1905–1987) of Main Amana spent time at Wood's Stone City Art Colony during the summers of 1932 and 1933. Both men painted Amana scenes. While serving in World War II Eichacker, who had once aspired to being a commercial artist, painted watercolor portrayals of Australia, where he was stationed. Tragically, Eichacker was killed during the closing months of the war. Schoenfelder continued to paint one or two Amana pictures a year, and was honored as one of the last surviving Stone City Art Colony students shortly before his death.

In the 1960s and 1970s a group of Amana residents, some as part of an adult education program, took up painting as a hobby. The works of Jacob Zimpelman, Raymond Berger, Mary Wendler, George Mittelbach,

Kathryn Hayes, Rozella Hahn, Mary Jeck, Nora Foerstner, Carl Kolb, Lena Leichsenring, Mildred Meyer, and others offer interesting depictions of Amana and Iowa landscapes.

Ruth Schmeider (1922–), daughter of Middle Amana photographer Dr. Christian Herrmann, followed in her father's artistic footsteps and has played an influential role in painting and actively promoting the arts in the Amanas. Her oils, watercolors, acrylics, and color pencil techniques portraying Amana scenes have been described as having particularly good composition, a quality found in the photographs of her father, who helped open the doors to freer artistic expression. Schmieder's landscapes reveal the influence of painter Andrew Wyeth, with their careful brushwork and composition. In more recent years, Schmieder focused on miniature paintings, both on canvas and on small wooden and porcelain eggs.

Artist Gordon Kellenberger (1942–) was fortunate in that his maternal grandmother, Marie Herrmann Ratzel (1890–1977), was skilled in drawing, music, needlecraft, and painting. She has often been described as a *naive* folk artist, much in the style of Grandma Moses. She spent many hours encouraging his drawing and sketching when he was young. In addition to the use of other media, Kellenberger concentrates on the use of pastels of vibrant hues to produce contemporary, stylized Amana scenes and the Iowa landscape. Free-flowing lines are often superimposed on more rigid verticals and horizontals to create striking linear contrasts.

He also enjoys spending many hours at a potter's wheel, a renewal of another craft pursued by only two potters when the Society was in Ebenezer. Kellenberger taught art in the Amana public schools for more than thirty years and in 1978 was the leading force in founding the Amana Arts Guild, an organization that has saved some of the Amana crafts from disappearing altogether while encouraging the folk and fine artists of today to expand the Amana artistic tradition.

Jack Hahn (1940–1997), a descendant of Friedrich W. Hahn, the clock maker, became well-known for his paintings of Amana and wildlife and for his wood carvings. Two of his works were selected for the Iowa duck license stamp. Madeline Roemig Bendorf (1931–) excels in painting the gardens, streetscapes, and buildings in oils and pastels.

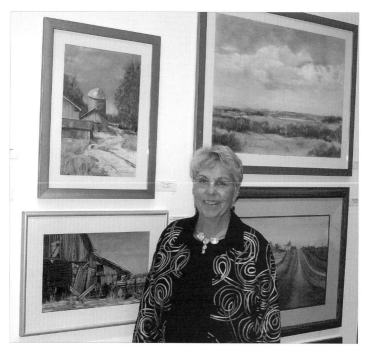

*Madeline Roemig Bendorf is shown with her
colorful pastels of barns and landscapes.*

Newcomers have created studio space in historic buildings. Michele Maring Miller, a well-exhibited watercolorist and oil artist, has converted the 1871 village sandstone church in West Amana into a spacious studio and gallery. She has been painting and drawing scenes in Amana for most of her life. Troy Thomas has likewise converted a historic communal kitchen in Homestead into a studio and gallery. Galleries and new shops often open in the Amanas and feature works by regional artists. Artists and artisans of different crafts, including leather, metal, and stained glass, are finding the Amanas to be a nurturing home.

The works of artists, writers, and photographers have added much to the present day-understanding and knowledge of the past. The arts have not only been satisfying creative outlets for numerous individuals, but also have and are adding to the history that belongs to the people of the Community of True Inspiration.

Handcrafts
of the Amana Women

A Woman's Work Was Never Done

In some ways the role of Amana women was not greatly different from that of other rural Iowa women in the pre-1920s. Aside from their religious obligations, the women were responsible for clothing the family, caring for the children and the aged, and making their houses homelike. They cooked meals in the communal kitchens and washed clothes.

By making handcrafts women could produce items needed by home and community and yet socialize with each other. Resources were limited, but the women maximized the possibilities and were willing to expend timeless effort in doing so. They had to work with what they had. To keep their families warm, they made comforters from calico and filled them with wool sheared from sheep raised within the community. They crocheted doilies and table covers, they embroidered religious quotations and sayings for wall hangings, and they made pictures from seeds grown in the gardens and fields. The women cut fabric from worn clothing into strips, sewed them together, and rolled them into balls in preparation for weaving rag carpeting to cover the floors. They hooked or crocheted throw rugs.

Feather Ticks and Quilts

Iowa winters can be cold. As a child, I remember the warm, secure feeling of having an Amana quilt (comforter) on my bed. It was soft, luxurious, and wonderfully warm. In the mornings, sometimes before I got up, my eyes would follow the diamond shapes or floral designs incorporated into the quilting pattern hand-stitched in the center of the comforter. In summer, when it was not in use, it was stored in a cedar-lined closet on a shelf specially reserved for it beside an unused feather tick of an earlier day.

During the first early years of Amana, the women would set aside an empty upstairs room or two in a house in each village to strip chicken

and duck feathers for ticks and pillows. The farmyard feathers were practical as they were readily available, no cost was involved, and they were an ideal, lightweight filler or stuffing material. Such bedding was considered to be so valuable that it was handed down from generation to generation. At such time as an outer covering needed to be replaced, a new one of calico or ticking was sewed and the feathers reused. Stories abound about the occasional transfer of feathers from an old tick to a new one, a major undertaking as the feathers always tried to get away.

Women also made the traditional top bed cover, called a quilt, by sewing together two widths of cotton fabric, and then sandwiching a layer of wool batting from the mills between the two outer layers. Most quilts required between two to three pounds of wool and ten yards of fabric. The outside fabric was usually a plain weave solid color sateen or printed calico from the calico print mill. My comforter happened to be a beautiful dark brown cotton sateen. Special summer quilts, filled with a cotton batting, were also made.

The fabric to be quilted was stretched over a square quilt frame, consisting of four boards with holes drilled at one-inch intervals. The quilt fabric was attached to the frame by basting it to a strip of ticking tacked to the wooden edge. As the quilting progressed, the women pulled the iron pegs holding the frame together, wrapped the complete quilt around it, and then refastened the frame with the pegs.

Before quilting began, the women used a stencil to make a chalk drawing of a series of curvilinear lines or floral designs on one side of the outer fabric. These designs ranged from flowers to hearts and lilies. Other popular designs included the *Schlangen Kranz* (serpent pattern) and *Pfiefe*, a pattern that consisted of a series of interlocking pipes. A diamond pattern, known as *Karo* for the center field, was introduced by means of a chalked string being snapped against the outside surface of a yardstick so as to create straight guidelines for the quilters.

The skilled hands of a few ladies would place endless tiny stitches along the chalked lines of the pattern and sew the three layers together with quilting needles. When the quilting was finished, the quilt was taken off the wooden frame and the raw edges turned over and hand-sewn in place with a blind stitch in a process called *Stoffiering*. As years passed, the Amana quilt replaced, in part, the traditional feather tick

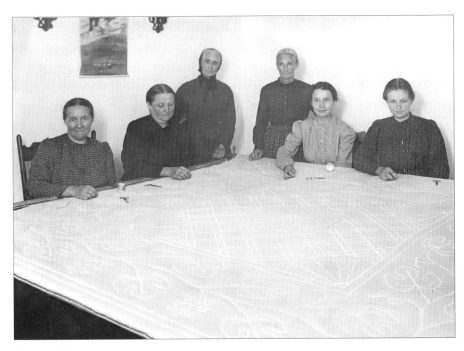

Quilters in the communal era quilt a solid color fabric.
This tradition continues with today's quilters.

the Inspirationists had known in Germany. Even though patchwork quilts were popular elsewhere, such as in the New England states, they were not made in Amana in the early days, probably because it took longer to assemble and stitch the patches together.

Every young bride received two summer and two winter quilts upon her marriage, along with twelve sheets, six table cloths, and other small items. The primary purpose of the quilting party was to quilt. However, the hours that the ladies spent with one another also served a social purpose. They even seemed to quilt faster when the conversation was lively. Coffee and "sweets" completed the afternoon.

Today, the Amana Church quilters produce quilts for sale or donation, although these are larger than the quilts of the communal era. Additionally, many Amana women continue to gather to quilt for themselves or their families. Elizabeth Parvin and Caroline Trumpold of Middle Amana have both been active in teaching classes and demonstrating quilting for the Amana Arts Guild.

Knitting, Tatting, and Crocheting

The belief that all creative handwork was important and honorable was taught to children at an early age. Skills that produced utilitarian end-products were encouraged. Knitting was a basic form of needlecraft, the technique that could be used for producing many different kinds of essential and wearable items.

During the winter months the boys and girls of the elementary classes, as young as six and seven years old, were given daily knitting or crocheting lessons as a part of the regular academic curriculum. During *Strickschule* (knitting class), a special knitting teacher, usually an older or single woman, taught the children. Each child had his or her own basket to neatly hold the yarns, knitting needles or crochet hooks, and his or her current project of making mittens, socks, stockings, or gloves. At the end of the daily lesson, each basket was stashed in its own little cubicle in a bank of shelves or side by side along the top of an Amana-made bench, always in the same spot. The children could fulfill most of the community needs using the black, blue, and brown yarns from the woolen mills and the knitting needles crafted by the blacksmith. As the girls matured, they spent their free time making doilies and edgings for pillowcases and sheets that they would put in their hope chests. As adults, the women often found knitting or other handwork a satisfying outlet and would create items more difficult to make, such as the black fringed shawls and black winter caps to be worn to evening worship services.

An elderly friend said that at one time she asked a young lady living nearby to help with the household cleaning. Since no actual money changed hands among Society members, the older lady, in return, helped the young girl solve some knitting problems she was encountering while trying to make a dress for herself.

Knitting even extended to rug making. While it was not common practice, a few ingenious ladies sewed together strips of fabric cut from worn clothing, dyed them, and knitted the squares for rugs.

Tatting and crocheting were two additional handcrafts shared by mothers and older daughters. Tatting, a process that produced a handmade lace by looping and knotting a single thread with the help of a bone shuttle, was time consuming. Hours of patient work would produce only a few

inches of a series of small continuous circles knotted together. The caps the women wore to church were often edged in black tatting. Excellent eyesight was a prerogative for most, at least until the tatters were experienced enough to do it almost by touch rather than by sight.

Women crocheted scarves and mittens with heavy yarns from the woolen mills while the cotton knitting thread needed for the doilies and covers for tabletops and chests came from the general store. The crochet patterns varied a great deal. Some designs were radial, some floral, while others were a combination of open and closed work. Women also engaged in filet work, another type of crocheting used in making tablecloths that they often sold. It was a kind of lace with geometric designs made by superimposing patterns on a square mesh ground. Most ladies were sufficiently skilled so as to improvise their own patterns.

Crocheting was also a technique in rug making. Strips of fabric from clothing no longer wearable were sewn together, rolled into balls, and made ready for someone to crochet a long-lasting round or oval rug for a heavily trafficked doorway. The rugs were started with a coil in the center with continuous crocheting in a spiral pattern. The challenge for the inexperienced was that the center would tend to pop up and not lay flat. Seasonally, cornhusks would be braided into coarse-type floor mats used for cleaning the shoes of the outdoor workers so that dirt and mud from the fields would not be transferred into the homes.

As the years passed, women had more time, so they expanded their crafts. One ingenious lady, Louise Hahn Rettig (1872–1957) of Middle Amana, crocheted a great many beloved miniatures such as farm animals, trees, and barnyard settings. Today, several Amana women continue to knit and crochet using traditional patterns. The work of craftspeople such as these is available for purchase through the Amana Arts Guild.

Textile Production

Two basic fabrics were important in the early Amanas: woven woolens and cotton calico print, a type of muslin. Weaving woolens began in one of the European estates and was so successful that the Inspirationists moved the equipment to Ebenezer and later to Amana. Dyeing and printing calico also proved to be a successful undertaking, representing a major tech-

nological development in the middle of the Iowa prairie in the last half of the 1800s. The income these businesses provided was badly needed to sustain the seven villages.

The Woolen Mills

In 1838, woolen textile production began at the Armenburg estate, one of the places of refuge rented by the Inspirationists in Germany, then transferred to Ebenezer. In Iowa two mills were established in the early 1860s, one in Amana and the second in Middle Amana. The former was destroyed by fire in 1923 and rebuilt, and the latter closed in the early 1940s and eventually became the site of Amana Refrigeration, Inc. The Amana farms raised some three thousand sheep, but the wool could not supply the need. Additional raw wool was purchased from vendors who had secured it from southern and western states and as far away as Australia.

The early finished products included heavy wool flannels of dark colors for shirts for outdoorsmen, farmers, and miners, as well as ladies' cloth for winter garments and wool blankets. The flannels were gradually replaced with high-quality men's suitings, some for use within the Society. A large quantity was sold nationwide, including at New York and Chicago retail stores. Amana tailors made the men's wool suits for "Sunday best." An additional, substantial national market was developed for wool batts that were used as filling for comforters.

During the years of full operation, the woolen mills were the best-known business operations of the Society. Most, not all, of the manpower used within the mill was male, although the ratio gradually changed as women entered the factories in larger numbers following The Great Change.

Calico Printing

Calico was the cotton fabric of the Amanas in the 1860s and the years that followed. The Society purchased bolts of unbleached muslin from the South from 1856 until 1881 and the East from 1882 until 1916. It was shipped by rail to a warehouse in Homestead, then transferred by horse and wagon to buildings in Amana, two of which now house part of the Amana Furniture and Clock Shop. The fabric was processed by a series of

Printing blocks for calico used in the early days before production was mechanized.

washings; dye baths of black, brown, or dark blue dyes; printing; and inspections. One of the printing processes, discharge, involved running endless yardage through copper-studded printing rollers that bleached out lace-like designs and created a variety of interesting and neat white or light blue "print" patterns against the dark backgrounds. Another form of dyeing used, resist, involved printing designs in paste on the fabric and then dyeing the cloth. The paste resisted the dye, leaving a white design. The designs were generally small, sometimes geometric, other times stylized floral patterns, perhaps encased in narrow stripes. Many of the more than one thousand designs were the work of J. George Erzinger (1837–1899), Gottlieb Prestele, and Oswald Zscherney (1846–1938).

With a continuing need for cash to buy supplies that could not be produced within the seven villages, the Society cultivated an outside market for printed calico from New York to California. More designs were added and sales catalogs prepared. Several men became sales representatives for Amana calico prints, as well as for woolens. At its height in 1891 the total operation was housed in eight buildings and produced some four thousand to forty-five hundred yards of printed calico per day. The fabric sold from six cents to twenty-five cents a yard. Production continued until World War I, when a German submarine carrying the dyes and needed chemicals from the I.G. Farber Company arrived in Baltimore. The dye

in this last shipment kept the mills running an additional year, but once the supply had been exhausted the mills simply closed.

The dresses of the women required seven to eight yards of fabric and the style never changed. The garment was one piece with front button bodice and long-gathered skirt joined by a stitched-in belt. The round neckline was high and sleeves long and fairly straight.

Grandmothers, mothers, and daughters all had the same type look-alike dresses of a dark calico print. The dresses intended for church were made of a lighter weight and softer calico while those for outdoor and household duties were heavier.

Calico aprons, white or printed depending on the tasks of the moment, were worn over the dresses to help keep them clean and make them last longer. The aprons always looked fresh, and appeared as a necessary component of a woman's daily attire. Calico shawls were worn over the dresses in summer and wool flannel shawls in winter. On the day of a wedding, always a Thursday, the bride wore black. This practice continued until 1948.

Sunbonnets

Another signature item of dress for the women was the calico sunbonnet. Every grandmother, mother, and daughter had several of the practical outdoor head coverings for trips to and from the communal kitchens, and work in the gardens and fields. The young girls even wore them to school. The bonnets were rather unique; long visors to protect the face from the sun were attached to gathered sections of calico to shade the back of the neck. The sunbonnet was so much a symbol of Amana that a silhouetted profile of "the woman with the bonnet" was an official trademark.

Infants were kept snug and safe in special white blanket pouches. The covering had a series of buttons on either side and edges trimmed with lace or tatting.

For many years, Amana villages maintained *Nahe Stube* (sewing rooms), where community seamstresses made shirts and bed linens for the hired men. Each room contained sewing machines that were also available to the women of the community for their own use. All the women knew how to sew. Mothers taught daughters that fine sewing skills were of the utmost importance.

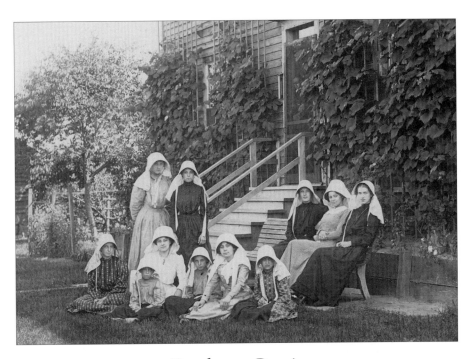

Dutchtown Dearies
This was the title given this photograph of women wearing bonnets.

Embroidery

Some grandmother lovingly and expertly embroidered the colorful Bible verses hanging on the walls of the Amana Museum, known as *Haus Segen* (house blessings). Such verses, mottos, and sayings related to morality, and words of wisdom were often cross-stitched or created with other plain and fancy stitches on a light-colored background fabric, were framed in walnut and hung on living-room and bedroom walls. Sometimes these mottos were "sticked" on punched paper in a style known as Berlin work. Frequently, the creator would add pressed flowers and other items to create a sense of depth. The German texts, such as *"Er sorgt für euch"* ("He will care for you") or *"Ein Frohlich Herz eih Friedlich Haus das macht das Glück des Leben aus"* ("A happy heart, a content home, that's what makes fortune all through life") were daily reminders of the values and teachings of religion. Many framed cross-stitched depictions of a stag or stags in a forest could also be seen hanging on an otherwise bare wall, a theme carried over from former days in Germany.

Seed Pictures, Shell Pictures, and Yarn Flowers

A very different kind of handcraft that Amana women enjoyed was making seed pictures with seeds collected from flowers and weeds that were readily available in the lawns and fields, as well as split pits from fruits and grains. The various shapes were glued to a backing in such a way as to suggest a flower, floral arrangement, or wreath. Children helped pick and sort the plentiful pumpkin, poppy, bean, and sunflower seeds and lay them out to dry. Kernels of corn or grains of wheat were sometimes added for color or textural contrast. The finished project would be placed in a walnut frame, handcrafted by a woodworking hobbyist or a cabinetmaker, and hung on the wall.

Occasionally a young lady would receive a unique gift of small shells, a gift cherished in the midlands of the United States. To display the shells, the young *Schwester* (sister) would arrange them to resemble a flower or bouquet, glue them in position, and have the project framed in a shallow shadow box for the wall. A second and similar type of wall accessory involved arranging colored yarns in such a way that the finished project also suggested flowers. This process was known as stump work, and involved using yarn, thread, and wire to create a three-dimensional effect.

Another wall accessory was the newspaper rack, even though the Inspirationists were not encouraged to read newspapers. The racks were essentially two finished, flat pieces of wood hinged along the lower edge with an embroidered, painted, or incised saying or floral design on the front.

Mothers began teaching their seven- and eight-year-old daughters various kinds of embroidery stitches such as chain stitching, cross stitching, cable stitching, buttonhole crewel work, and needlepoint as well as how to darn socks. It was joyful to work with their fellow members. As years passed, they had more leisure time and expanded the range of their arts and crafts.

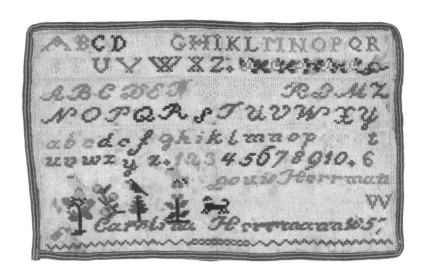

Above: An 1857 sampler by Caroline Herrmann created in the Amanas after the people moved from Ebenezer, New York. *Below:* A seed painting by Louise Rettig, daughter of clock maker Friedrich Hahn. Translated from German, the seed painting reads, "In our home, there is contentment and true love abides."

Easter Specials

Easter Sunday was a day for simple, yet serious, religious services for all, adults and children. The children, however, would have the fun and excitement of a special treat that day: the annual visit from the *Oster Haas* (Easter bunny). There were only a few other occasions that could light the eyes and faces of the children more than the "find" of beautiful, brightly colored Easter eggs topped by a very large sugar cookie in an Easter basket. Unbeknownst to the youngsters, preparations began in the communal kitchens a couple days before Easter. Each kitchen had an older woman as the kitchen boss, an assistant, and several 14- and 15-year-old girls to do much of the footwork and help with such special preparations as coloring Easter eggs. Before the holiday, several of the girls started gathering the needed supplies. Some collected the brown eggs of the hens in the chicken houses, while others went to the cabinet shops to get powdered glue or to the woolen mill to get dyes of various bright colors. The cabinetmakers regularly had the glue powder on hand as it was used in furniture making. The girls, with the assistance of the dye-house manager, chose the dye colors from the big barrels at the woolen mill that were used for the brightly colored woolens sold to markets outside the Amanas.

After the materials were collected, the glue and water were heated together, poured into small containers, and mixed with the dye. The colored solutions were allowed to cool and thicken overnight. The eggs were boiled and, while very hot, were added to the dyes in individual dishes of dye to coat the surface of the shells for the beautiful bright blue, green, and red Easter eggs.

As they were turned in the liquid dye, the colors became better and brighter! The next morning, the eggs were cooled and ready for the baskets. Meanwhile, sugar cookie dough was being mixed and rolled out for cutting. The sugar-cookies contained lots of butter and sugar. At some earlier time the tinsmiths of each of the villages had handcrafted cookie cutters in the shape of bunny rabbits—large ones, some twelve inches in length. The kitchen helpers put the eggs in the baskets, topped them with a bunny cookie, and hid the baskets in all the "hard-to-find" places they knew.

Handcrafts
of the Amana Men

School-age boys were encouraged to stop by the various craft shops whenever they had the inclination and free time. The older men treated them well and would explain aspects of their crafts. The boys whose primary interest was farming might be asked if they would like to help feed the animals. Those who seemed to have marketing skills might be directed toward helping stock the shelves of the general store, and the ones who were fascinated with sawing and joining would be encouraged by the cabinetmakers to try their hands at assembling simple benches or boxes.

The villages were sufficiently small and interconnected for the elders to know which young men had interest in specific crafts, their apparent aptitude, and which of the workshops needed young men for the future. The elders made every effort to match young eighth-grade graduates with their interests, abilities, and the community requirements. They also chose young people for higher education leading to such professional pursuits as pharmacy and medicine.

All the young boys were encouraged to whittle and make simple toys such as whistles from the plentiful fallen tree branches; those a little older enjoyed making sling shots. Whenever the occasion arose, a father would encourage his son to be his helper in home projects ranging from making a birdhouse to making a Christmas pyramid. Many showed interest; however, only a small number could justifiably be trained as cabinetmakers. Many of the remaining worked with wood as hobbyists or carpenters.

All in the Society had access to the workshops, tools, and wood as these materials were community property and individuals could pursue their personal projects as time permitted. The hobbyists sometimes chose to work individually on their own projects; other times they would seek the help of a craftsman such as a cooper or a machinist for advice or help.

The home crafters made a wide variety of items that ranged from the *Gartestock*, a simple turned piece of wood used for attaching string when marking straight rows in planting garden seeds, to the much more elaborate lawn gliders (swings). Spinning tops for children, together with *Setz Holze* (tools used for planting gardens), were popular items for men skilled at wood turning. Some enjoyed making trellises for the exterior walls of the houses, work benches, basement bins for the winter storage of vegetables, and drying racks. Others would make handles for garden or farm tools, or knives along with the help of the blacksmith or whoever was needed. The woodworker might combine his efforts and know-how with those of a wheelwright to make the wheels and a box for a child's gift of a wagon or wheelbarrow. Chests made by the home crafter were welcome items because case pieces for storage were relatively rare in the early days.

Those with a flair for the more decorative items would make corner wall cabinets or shelves to hold small bric-a-brac. They often made shelves to hold the family shelf clock in the living room, or whatnot shelves to hang in the corner. The hobbyist with a little greater expertise would make clock cases and even incorporate a little inlay. Young men who were in training to be cabinetmakers and thinking of marriage would often make hinged, lidded wood boxes for their sweethearts.

A Family of Woodworking Hobbyists and Skilled Artisans

It was not unusual for the youth of a family to develop diverse hobbies and sometimes working careers related to their parents' activities as well as to their own interests. Herman and Mary Setzer Berger of South Amana and their descendants are an example of such a family. As a young man Herman Berger had shown signs of interest in agriculture, forestry, and the out-of-doors. The work assignment given to him by the elders was in the large Amana farming operation. As the Berger family matured, a weekly Sunday afternoon walk in the wooded areas and fields of Amana became a favorite activity of the parents and three sons: Fred, Dan, and Adolph (A.T.). They devoted much time to identifying plants and trees while on these walks.

As a very young person, the eldest son, Fred (1906–1982), was attracted to mechanical devices, especially farm machinery. At eighteen, as a hobby, he built many pieces of household furniture from available

woods, especially ash, with tools and equipment he had made. The elders took note. During his adult life, he became a self-taught machinist and could craft almost any piece of mechanical equipment that was needed. His son, Dean (1937–1994), later became skilled in woodcrafting in his own right, while grandson Dave recently completed a series of reproduction of Amana door latches for sale by the Amana Arts Guild.

The second son, Dan (1907–1996), was one of the school boys who frequently stopped by the South Amana cabinet shop for an hour or so and helped with any tasks that an interested and adept thirteen- or fourteen-year-old could manage. After graduating from school Dan was assigned to work in the cabinet shop. He liked his assignment, but after a few years felt he needed to take a look at the outside world and went to Chicago to work.

Within a short time he decided that life in Amana would be better for him, and he returned to Main Amana, the home village of his wife, Marie. He was assigned various jobs, but discovered he liked those assignments in which he worked with wood the most. After a fortunate sequence of events, he became general manager of the Amana Furniture Shop.

Dan was an expert craftsman and highly respected for his abilities. He enjoyed the challenges offered in the unusual and more difficult types of construction techniques, such as creating tambour tops for rolltop desks. Later he moved to another Society owned and operated business that involved making case furniture for kitchens and businesses and various types of millwork.

A.T. Berger (1908–1996), the third son, played an important role in directing the education and leisure activities of children. His vocation was that of a teacher; his avocation was that of a toy maker. He taught school for twenty-five years. Later he became a rural mail carrier and was a member of the Committee of Forty-Seven, the group of Amana leaders chosen to plan the 1932 Great Change from communal life to capitalism. Occasionally, he also wrote poetry.

Woodworking had become a hobby during his early years and played an increasing role throughout his life. His workshop and display area were in the former Upper South Amana Hotel. In the middle of piles of sawdust and wood shavings, A.T. Berger created wooden trains and cars, miniature horse-drawn sleighs, rocking horses, flared wooden

bells with metal liners and clappers, candy dispensing machines, and children's furniture. He often had a nice little story to enhance the intrigue that one of his wooden toys held for some fortunate little boy or girl.

As a very caring and kind person, this teacher, hobbyist, toy maker, rural mail carrier, and poet would often leave a poem in the mailbox of an ailing fellow Inspirationist to extend a word of encouragement and his good wishes.

Solid walnut cutout by Dan Berger

Amana Arts, Crafts, and Furniture Today

Although American life has changed considerably, a thread extends from the arts and crafts of early Amana to the present day. After the change from communalism to capitalism in 1932, the artisans had to turn to a different lifestyle, both at home and work. The new system, with its private enterprise, required profit margins and effective marketing. The workshops soon became either Society owned or privately owned, and no longer had a communal basis.

The Cabinet Shops

Following the end of the communal system, the Amana Society entered into commercial furniture production by expanding the cabinet shop located in the village of Main Amana. Although cabinet shops in the other villages continued to operate for a few years, furniture production centered in Main Amana, in the buildings that formerly housed the Amana Calico Mill.

By 1936, with twelve cabinetmakers at work, the Society issued a catalog featuring reproductions of traditional Amana furniture made in the Main Amana shop. In some cases customers submitted their own designs for production; for example, Iowa artist Grant Wood designed and ordered a set of dining room chairs to furnish his Iowa City home.

In the late 1950s, the Amana Society began to place more emphasis on sales and marketing. Dramatic growth led to an expansion of the production areas and addition of a display area capable of exhibiting more than 150 of the clocks that became the hallmark of the shop.

Today, the Amana Furniture and Clock Shop continues to produce handcrafted furniture from cherry, oak, and walnut. While the solid pieces of wood used for turning may come from the Amana forests, much of the wood used is purchased from outside suppliers. Each item is crafted by a single craftsman from start to finish, and is individually

signed and dated. Dovetails and mortise-and-tenon construction are features, as is the satiny hand-rubbed finish. Over the past few decades the shop has produced some limited-edition items, such as the Friedrich Hahn wall clock, the Sandstone grandfather clock, and a grandfather clock named for the Prestele family of artists, featuring reproductions of Prestele lithographs on the moon dial.

In 2004 the Amana Furniture and Clock Shop made a dramatic departure from its past designs by introducing the Cooper's Collection, a furniture collection with contrasting light and dark woods and curving lines that were inspired by the rounded barrel staves produced in the village cooper shops. With its contemporary look, the collection is designed to appeal to changing tastes in the increasingly competitive fine furniture market.

Two private family-run furniture companies have established reputations for quality craftsmanship. The first, Krauss Furniture Shop, was founded by Dave Krauss and his children, Marvin and Virginia, near South Amana in 1956. The shop, now housed in a 20,000-square-foot building, is still a family-owned and operated business.

As at the Amana Furniture Shop and Clock Shop, furniture is made of the traditional walnut, cherry, and oak. Krauss produces chests, tables, highchairs, rockers, footstools, beds, desks, hutches, carts, and many impressive clocks. The Krauss shop also takes custom orders.

Schanz Furniture and Refinishing was founded in 1966 by West Amana native and fifth-generation cabinetmaker Norman Schanz and his wife, Joanna. Schanz began his career as a cabinetmaker at the Krauss Furniture Shop, but formed a furniture refinishing business of his own. As the only area refinisher, Schanz soon had more business than he could handle and left his work at Krauss for the new venture, housed in a modern building at the edge of West Amana.

Joanna Schanz's interest in traditional crafts such as broom making and baskets, profiled elsewhere in this book, led to a related business, the Old Broom and Basket Shop, located near the original Schanz Furniture Shop. In 1979, the Schanz operation further expanded with the addition of a large new production facility and showroom near South Amana.

While Schanz Furniture and Refinishing continues to refinish furniture, it is also known for crafting a variety of furniture, including tables, rockers, desks, chairs, chests, and whatnots. In the early 1970s the company built reproduction desks and chairs for the restoration of the University of Iowa's Old Capitol building. Thirty years later, in 2002, the company refinished the furnishings of this Iowa landmark after a fire damaged the building and its contents.

Schanz uses a variety of woods, including oak, walnut, cherry, hard maple, butternut, hickory, and ash. Out of deference to his neighbor, the Krauss Furniture Shop, Schanz does not produce clocks. One landmark production of the Schanz company is an eleven-foot-tall, 670-pound solid walnut rocker constructed in 1983 and now a popular visitor attraction at the West Amana shop.

German-born Walter Kraft, who worked for both the Amana and Schanz furniture shops, later established himself as an independent cabinetmaker at his home in West Amana. Kraft, who while at Schanz's did much of the work on the Old Capitol restoration project at the University of Iowa, specializes in intricate inlay work, or marquetry. Alan Trumpold, a South Amana native, produces a variety of custom-ordered pieces from his home shop in the village of Homestead.

The cabinet shops of today, both Society owned and privately owned, have furniture styles inspired by the old communal furniture as well as designs influenced by eighteenth- and nineteenth-century America, the Queen Anne period of England, Shaker, and Stickley. Upon request, the cabinetmakers will also reproduce designs of the past, such as a special old desk or antique chest.

Today, one can also find many interesting accessory items such as spoon racks, trays, salt boxes, sconces, bookends, lazy Susans, napkin presses, trivets, paper towel holders, spoon holders, games, noodle cutters, walking sticks, candlesticks, and the like. Many of the trays are of the same general design as the preparation trays that the women used in cleaning and cutting vegetables in the communal kitchens, but they are crafted of finished walnut, cherry, and oak.

The Clocks

My grandfather's clock was too large for the shelf,
So it stood ninety years on the floor,
It was taller by half than the old man himself,
Though it weighed not a pennyweight more.

This poem is credited to Englishman Henry C. Rock and was written sometime after 1878, at a time when clocks and watches were becoming popular in the Amanas. Today the tall grandfather and grandmother case clocks, as well as wall, mantel, and shelf clocks, can be found in most, but not all, of the cabinet shops. Cabinets of top-quality solid hardwoods are built to house German-made movements and dials. All the steps—from sawing to sanding to the final finishing—are done with the same meticulous craftsmanship as in the past. Choices of style for the timepieces vary with optional finials, faces, pediments, chimes, inlays, carvings, and other enhancements.

Baskets, Broom Making, and Caning

Basket making, broom making, and caning are popular crafts that have been revived in the Amanas. Handmade baskets of many kinds, colors, and uses are being crafted daily, both in shops and in private homes. Many are of designs reminiscent of those used in the past, while many new shapes have been introduced. Classes, seminars, and demonstrations are held periodically by dedicated local artisans.

Caning is a time-honored skill that has gone hand-in-hand with chair making and repairing. The neat hexagonal patterns of the weave add an extra dimension to the patina of the walnut, cherry, and oak and are in great demand. Some of the artisans work in shops while others work out of their home.

The Artists

Amana artists of today are a combination of the descendants of the early Inspirationists and outsiders who have moved into the area. Both groups have maximized their studio spaces and galleries in historic workshops and homes. New media, colors, and uses of line and form can be found alongside décor from the past.

Many of the painters excel in using oils and watercolors, but also enjoy the results of pastels and acrylics. The potters have revived an art that was discontinued due to the lack of the proper kind of clay but today are creating the shapes and forms reminiscent of an earlier time. The photographers employ new techniques and approaches to their art. Stained glass and jewelry have been added. These diversified contributions are playing an increasingly important role in the Amana culture of the twenty-first century.

Handcrafts of the Amana Women

The role of the Amana women in our affluent economy of today has changed considerably just as it has throughout the rest of the United States. For many the focus is no longer quilting and canning vegetables; however, some still engage in their favorite handcrafts as a pleasurable leisure-time activity. Women who made yarn flowers are now more likely to make decorative wreaths for the holiday season. Knitting mittens with the customary star pattern on the back is largely for creating a traditional gift rather than a necessity. Making seed and shell pictures, and embroidered mottos are no longer a part of the daily life of Amana women.

It might be expected that the Community of True Inspiration would have had numerous candle makers among the various artisans and craftsmen. However, neither records nor memories show evidence of candle making, probably because other sources of illumination were available and more feasible. The small candles used on the Amana Christmas trees and Christmas pyramids undoubtedly came from external sources through the general stores. Today, Amana candle maker Terry Roemig has picked up the craft and creates candles of many sizes, shapes, and colors and sells them in her shop.

Dyeing and printing "Amana calico" was discontinued by the 1920s because the dye was no longer available due to the blockade of Germany in World War I and because the demand for calico had virtually disappeared. The woolen mill has reduced the size of its operation, but one can still observe the old looms producing the plain or twill weave woolen throws and blankets. In addition, the staff there has created many colorful craft items from bobbins, spindles, and yarns that are associated with the mills. Dolls, Christmas decorations and tree ornaments, centerpieces, and numerous other small craft items are also available. A computerized embroidery machine is kept busy putting names and logos on sweatshirts, banners, and tablecloths.

The Tinsmiths, Coopers, Blacksmiths, and Other Craftsmen

The presence of the metal crafters and the products they created were vital to the existence of the Community of True Inspiration. As the villages became established and the twentieth century approached, commercial products readily replaced tin kitchen equipment, wine kegs, and horseshoes.

Today there is a renewal of some of these crafts as crafts rather than for utilitarian purposes. One dedicated and well-recognized Amana artisan, Bill Metz, has revived the interest in tinsmithing. He makes lanterns for light posts, candleholders, the traditional Easter cookie cutters, star-shaped cake pans, and other such tin items mostly for decoration. The village blacksmiths, artisans who in earlier days came from within the Amana Society but more recently from the outside, create period hinges and hooks, decorative racks for drying the colorful ears of Indian corn, ornamental door knockers, wind vanes, yard stands, fireplace tools, stair railings, and numerous other home accessories.

The Home Crafters and Hobbyists

Woodworking is still an important hobby for many in the Amanas; however, just as in most societies today, individuals seem to have less leisure time. Some make items for their families while others make them for sale. Items for the commercial market often include boxes, whatnot shelves, footstools, picture frames, wooden utensils, such as spoons, and, occa-

sionally, larger items such as clock cases. Harvey Jeck's woodworking hobby has turned into a productive vocation. He spends many hours creating a wide range of toys, wooden eggs, bowls, cutting boards, bottle stoppers, pasta tossers, and birdhouses. He enjoys creating children's items such as wooden tops, marble mazes, games like tic-tac-toe, wooden toys, carved birds, farm animals, figures for nativity scenes, and Christmas pyramids.

Another favorite pastime is making miniature doll houses, complete with furniture, and farm settings, all with traditional little white fences. Grandfathers seem to get a special pleasure in making the traditional marble game, the *Klickerbahn*, and the traditional Christmas pyramid for the commercial market and for grandchildren.

Other hobbies and profitable ventures have developed from skills learned in a variety of earlier work experiences. For example, one retiree gained exceptional manual dexterity during his working years, leading to his crocheting white stars to decorate Christmas trees.

The Amana Arts Guild

The Amana Arts Guild is an arts organization with a special mission to sustain and nurture a living arts and crafts tradition in the Amanas. To accomplish this, the Guild has created a multigenerational program that has brought about a major crafts revival in such areas as tinsmithing, rug making, basketry, blacksmithing, woodworking, and needlework of all kinds. The program consists of authenticating traditional objects, identifying master crafts people, assisting in the transition of skills, and marketing the items.

Founded in 1978, the Guild has renovated the former High Amana church (1858) and adjacent *Kinderschule* (preschool). The organization operates an arts and folklife center on the main floor of the church. The center is used for educational activities relating to both traditional crafts and arts. Classes include lantern making, tinsmithing, quilting, mitten knitting, rug making, basketry, painting, and photography. An area in the former *Kinderschule* is a weaving studio. Craft skills are also fostered through a series of master apprenticeship programs organized by the Guild.

A gallery and museum sales shop in a unique attic space is located on the second floor of the High Amana Meetinghouse. The gallery houses

a number of rotating exhibits, while the museum shop sells traditional items. Each year the Amana Arts Guild presents a "Friend of the Arts" award to individuals who make important contributions toward the presentation and growth of the artistic life of the Amana community. This award is presented during the Guild's annual Festival of the Arts, a celebration of community arts and crafts.

Harvey Jeck built this lovely birdhouse combining different shades of hardwood. Jeck was among those who revived pyramid building in the 1970s in the Amanas.

The Amana Heritage Museums

In 1968, a group of residents of the seven Amana villages organized the Amana Heritage Society for the purpose of acquiring and retaining an accurate history of the Community of True Inspiration. As a result of their efforts and dedication, several historical sites now house and display items that have played an important role in the community's development—a showcase for arts, crafts, and furniture as well as a depository for historical documents. Each of the museums and sites focuses on a different aspect of Amana life.

The Amana Heritage Museum

The Amana Heritage Museum, shown below and left, the largest and most centrally located museum, is in the heart of the village of Amana. This museum complex is composed of a cluster of refurbished nineteenth-century buildings, including the Noé House (1864), a schoolhouse (1870), a woodshed, and a wash house. The spacious lawn is delineated by fences and accented with an occasional lamp post. The two buildings below served as schoolhouses in the communal era.

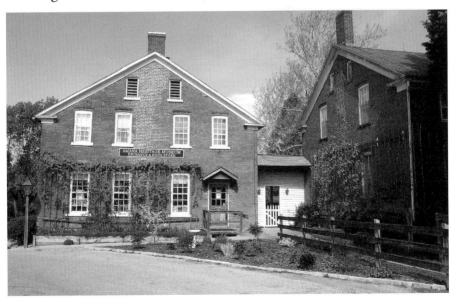

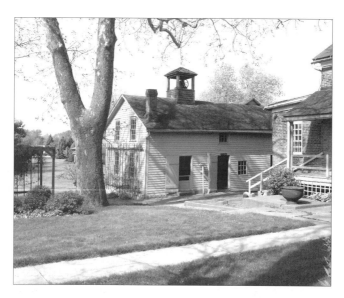

Above: The wash house and woodshed are by the Noé house.
Below: A walkway goes from the left and leads to the Noé house.

The interiors include many historical displays of arts, crafts, and furniture. The Heritage Society houses archives—including books, photographs, genealogical records, religious and governmental documents, and oral history interviews—available to researchers by appointment.

Homestead Store Museum

The Homestead Store (circa 1863) was a hub of commercial activity in the village of Homestead in the 1860s and the century following. It was the center for importing supplies that Society members could not produce on their own, and the center for exporting goods produced in the Society such as woolens, calico, onions, flour, and sauerkraut. The railroad was across the street from the store.

Today, this refurbished building houses items related to that commercialism, including some of the arts and crafts. Bookbinding equipment is on display, as are rug weaving, printing, tinsmithing, and carpentry exhibits, and wooden miniature Amana buildings. The second floor houses open storage of many wood crafts and furniture of the previous century—tools, desks, cradles, and trunks.

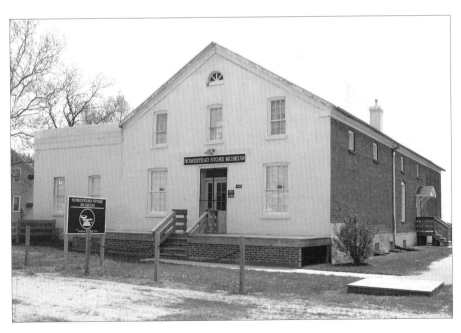

Homestead Store Museum

*The museum archives hold the works of many photographers who have
documented the Amana people. This 1937 photograph of a young
woman, Lucille Schaefer Kraus of East Amana, holding her hymnal and
Bible, is by John Barry of Cedar Rapids. She is wearing the traditional
dress of the women worn while attending church services. This custom
has continued into the twenty-first century. Once, each village had a
church with services led by the elders. Today, services are held at the
Amana and Middle Meetinghouses.*

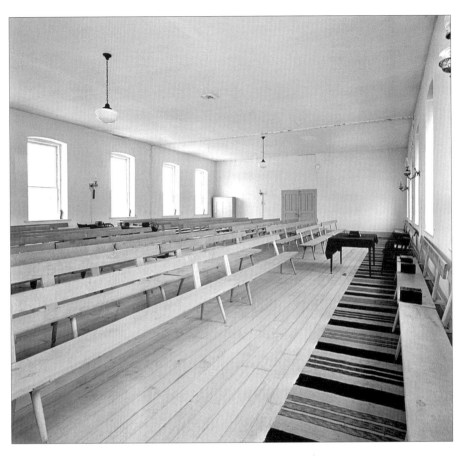

The Homestead Meetinghouse

Amana Community Church Museum

The Amana Community Church Museum, shown above, is in the village of Homestead. This church, or meetinghouse as it was called historically, is typical of those found in each of the other villages. The stately brick building has many of the same characteristics as the homes, but is larger and has separate entrances for men and women. The scrubbed white pine floors, blue calcimine walls, and deep windows provide the perfect backdrop for the plain benches and otherwise austere interior. The presiding elder sat in a spindle back armchair at the front of the room at a table covered with a heavy dark green cloth. Note the traditional handwoven carpet.

Communal Kitchen and Cooper Shop in Middle Amana

Each village had communal kitchens where Society members ate three meals and two "lunches" (basically coffee breaks) a day every day of the year, except Sunday, when they ate only three meals. Food was carried to the homes for the very young, the infirm, and the elderly. The menu did not vary week to week except to accommodate the abundance of seasonal foods. One such kitchen in the village of Middle Amana has been preserved as a museum. The *Rüdy Küche* (Ruedy Kitchen) has a large brick hearth, warming ovens, dry sink, an assortment of pots and pans, cooking utensils, tinware, dinnerware, and other equipment. The adjacent dining area with long benches and tables is laid for a typical upcoming meal.

Across the road from the communal kitchen is the cooper shop, which was built in 1863 and used by cooper Simon Murbach (1861–1941). A visitor can see the work area, tools, and some of the finished products such as tubs and barrels that the cooper crafted in the course of his daily work.

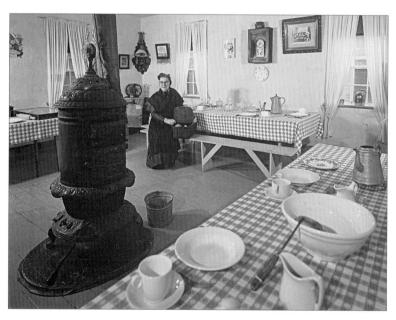

Communal Kitchen Museum, Middle Amana

Horse and harness display at the
Communal Agriculture Museum

Communal Agriculture Museum

As with the other Amana villages, South Amana was dominated by agriculture in its early years. Many barns, granaries, chicken houses, and hog houses were built there at that time. One of these structures, an ox barn (circa 1860), has been converted into the Communal Agriculture Museum. The large building was constructed with huge sturdy hardwood beams cut from local timber and fashioned with king-post trusses. The museum houses a variety of historical pieces of agricultural equipment. Other displays include the crafts of the blacksmith, harness maker, and wagon maker.

High Amana General Store

Each of the seven villages had a general store to supply the basic needs of residents beyond the food and housing the Society provided. The High Amana Store (circa 1857) has operated for over a century-and-a-half. The sandstone store was known as the shopping center for the residents and surrounding farmers, selling provisions ranging from sewing supplies, clothing, and tires to toys and appliances. A kerosene pump that supplied coal oil for the lamps found in the homes and communal kitchens can be seen inside the store. All income from this store is used to support the museums and programs of the Amana Heritage Society.

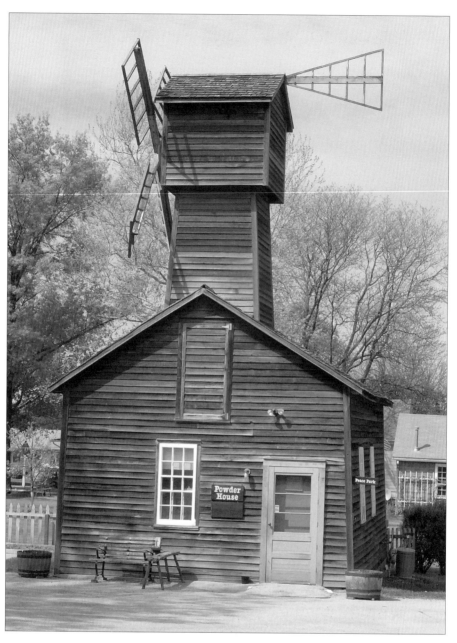

Of unknown purpose in the late 1850s, this building later was used for the manufacture of hog powder and pig medication. The windmill was reconstructed in 1989. The building currently is the workshop of a woodworker, R.C. Eichacker.

136 —

Interesting Village Architecture

Originally a warehouse for the Amana General Store, this building received a bell tower from a neighboring home in the 1930s. Bells tolled for beginning and end of workdays, for noon meals, fires, and to set watches.

The Amana Colonies were designated as a National Historic Landmark by the United States Department of the Interior in 1965. Unlike many other sites with landmark designation, the seven villages are a living landmark with a population of 1,600. They are often confused in the minds of visitors with the horse-and-buggy Amish. The Amana people have never been Amish, but a separate faith, an offshoot of Lutheranism. In addition to village residents, many commuters work in the Amana plant, in Middle Amana, now a division of Maytag, where appliances are manufactured.

Top: *Corn crib, East Amana. All Amana corn cribs date from World War II. A renovated corn crib in Amana serves as a visitor's center.* **Below:** *A weathered granary in East Amana. Built in 1925, it replaced one destroyed by fire.*

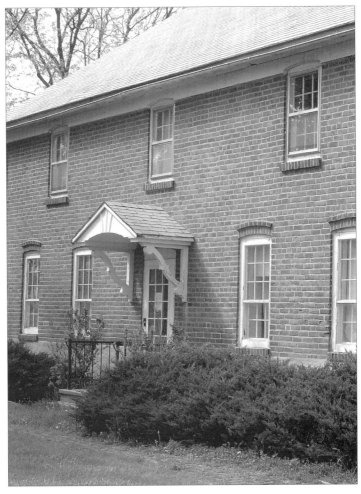

This photograph shows the entrance of a circa 1892 kitchen house in Middle Amana. The arches over the windows are typical of Amana masonry. Many homes have small porch hoods, as shown in this particularly good example, to protect the doorway during inclement weather. Note the nine-over-six window panes.

The Amanas in Bloom

Lily drawing by Virginia Myers

The Lily Lake, approximately 130 acres between Main Amana and Middle, was formed by an overflow of the adjacent millrace in the 1860s. Originally marshland, the lake flooded soon after the millrace was constructed.

Each July and August, the lake is covered by a profusion of yellow American Lotus Lilies. These large lilies were often used by native peoples as a food crop. At other times of the year, the lake serves as a haven for geese, trumpeter swans, and occasional bald eagles. The lake is encircled by the Amana *Kolonieweg* bike trail.

Seven Sisters

*Lithograph drawn in chalk on stone and colored
by William H. Prestele*

(*Courtesy Emma Setzer, Amana Heritage Society*)

Blue Vase with Strawberries
Unsigned watercolor by Joseph Prestele

(Courtesy Mrs. Ferdinand Ruff, Amana Heritage Society)

Bouquet Tied with Ribbon
Unsigned lithograph by Joseph Prestele

(Courtesy Pauline Schaefer, Amana Heritage Society)

Beilchen . Anemonen . Keiferkrone .

Flowers with Verse
Watercolor by Joseph Prestele

Violet, Anemone, Crown Imperial
Garden of my heart, now let us see what sweet fruit you bear
And how your flowers grow, which your faithful Jesus seeks
Give humility field Violet which fares so well with you
Give Hope the Anemone and Faith the Crown Imperial

(Courtesy Mrs. Ferdinand Ruff, Amana Heritage Society)

Poppies from Flanders Field

Larry and Wilma Rettig of South Amana have extensive flower and vegetable gardens. Their Cottage-in-the-Meadow Gardens are recognized by the Smithsonian Institution, Washington, D.C. According to tradition, a World War I soldier brought these poppy seeds home to Amana from Belgium. The Rettigs' vegetable gardens have many varieties from seeds carried from Germany by the Inspirationists in 1844 to New York, and then to Amana in 1855. These historic varieties of vegetables were grown in the communal gardens prior to The Great Change in 1932. Seeds include multicolor radishes, the flat European string bean, root celery, citrons to pickle, yellow egg lettuce, black salsify, ground cherries, and the Ebenezer onion once harvested for national sales.

Hammered Botanical Prints
by Larry Rettig

*This print shows an indigenous weed of unknown species
from the extensive Rettig gardens and grounds. Delicate details
from this print are printed on the covers of this book.*

The plants shown in this composite hammered print are garden asparagus fern, leather fern, wild daisy species, perennial geranium, and crab grass seed heads.

Larry Rettig makes these prints and others by hammering live plant materials into archival watercolor paper for original one-of-a-kind prints. Larry positions the plant material on the watercolor paper and then tapes it down with masking tape.

Using a small tack hammer, he begins pounding the tape-covered material to release its color and create an image on the paper. The amount of moisture is critical. Proofing also helps determine how hard he needs to pound to produce the desired image. If a flower contains too little moisture, there is little or no transfer of color from the material to the paper.

After allowing the paper to dry for a few minutes, the craftsman hammers more material into the paper until the desired image is complete. When the paper is dry, he sprays it with an acrylic fixative to protect the print and to make sure that any desired plant residue will adhere to the paper permanently.

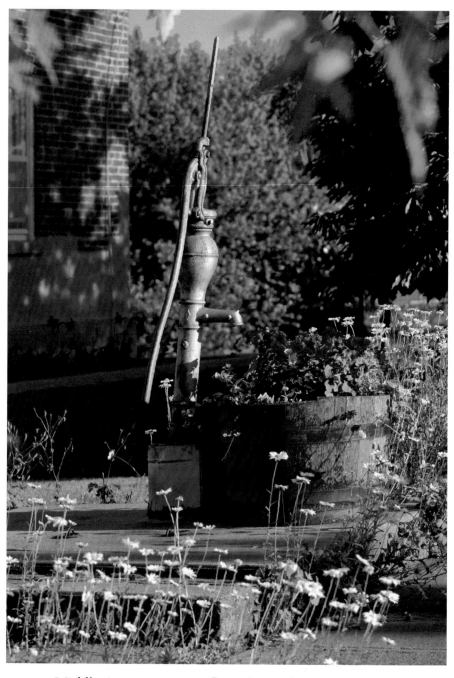

Middle Amana petunias flourish in a barrel surrounded by volunteer daisies.

Peonies and Pines in Upper South Amana

Elder Georg Heinemann planted the trees, above, that are on the grounds of the Don Shoup home plus an additional six-acre grove of pine trees in 1898. While early Amana religious leaders decreed that only fruit or nut trees should be planted in the villages, the colonists nevertheless planted *Tannewalder* groves of large pines, including a large grove in Main Amana that was harvested for gun stocks during World War II. Each village cemetery has a towering hedge of pines, reminiscent of the villagers' German homelands.

High on a hill, almost 920 feet above sea level, the Shoup home has a distant view of all the villages except Homestead. In 1908, author Bertha Shambaugh wrote, "The Amana village . . . is one huge German garden all aglow with quaint old-fashioned flowers. There are great rows of four o'clocks and lady slippers, borders of candytuft and six-weeks-stock, gorgeous masses of zinnias, marigolds, and geraniums, great pansy beds and rose gardens . . ."

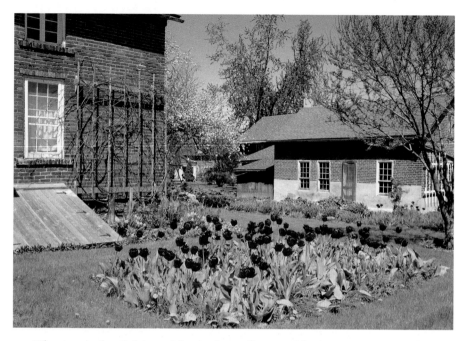

The grounds of this residence have flowers blooming spring to fall.

Above: The tulips and flowering trees are in South Amana, one of four Amana villages with a brick yard. All but four of the communal-era homes in this village were of brick. Even the village granary, a chicken house, and a wash house are built of brick. The building at left, with an entrance to the basement, is a residence. The building beyond the flowers was once a wash house. In recent years, South Amana has been known as the flower village.

Opposite: The small boy at right is Jordan Hans Heusinkveld, standing by the poppies and spring flowers in Amana wearing *lederhosen*. Alpine *lederhosen* and *dirndls* have become traditional costumes for festivals in German-American communities. Members of German and German-American bands at festivals wear this attire. Amana people wear the *dirndls* in parades and waitresses in some of the restaurants wear *dirndls*.

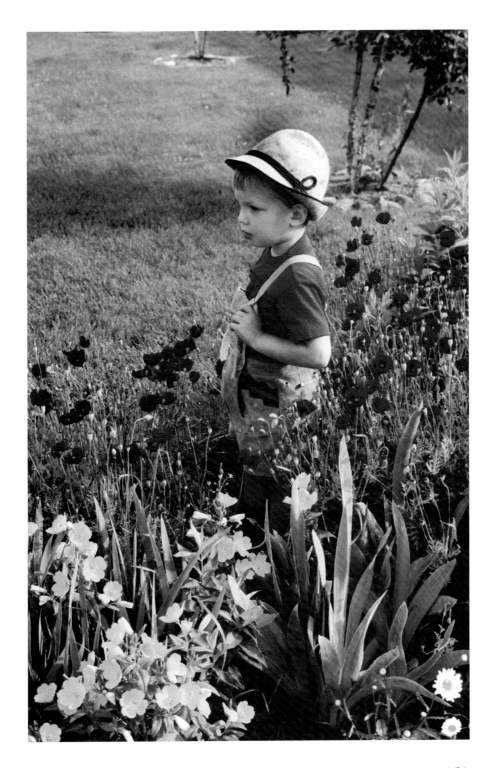

*Chain saw chickens stand guard by the geraniums
at the entrance to the Kellenberger pottery studio.
The old washing tub holds more flowers.*

Gordon and DeAnna Kellenberger accent their flower and vegetable gardens with Gordon's chain saw chickens, old wash tubs, and carved butterflies on old stumps. Gordon and DeAnna work in a variety of media. Gordon is a noted pastel artist who exhibits widely in the Midwest. He was instrumental in founding the Amana Arts Guild to preserve traditional crafts. DeAnna is a teacher in the Amana schools. Their sense of whimsy is reflected in the accents in their gardens.

The Old Wash House

A former communal village wash house at the Kellenbergers is now the couple's pottery studio. The trellis on the wall once supported climbing grapes for wines. For decades a white clematis has grown there. The garden markers, left, are fired pottery by DeAnna Kellenberger, who uses rabbit and wedding star cookie cutters for designs, originally created by tinsmiths for communal kitchen bakers. The star is a replica of the star cake pan.

Traditional flowers and plants enjoyed in the Amanas include alyssum, coral-bells, forget-me-nots, surprise and tiger lilies, scarlet hollyhocks, tulips, irises, hyacinths, orange poppies, geraniums, hydrangeas, snapdragons, peonies, white wild geraniums, and hostas.

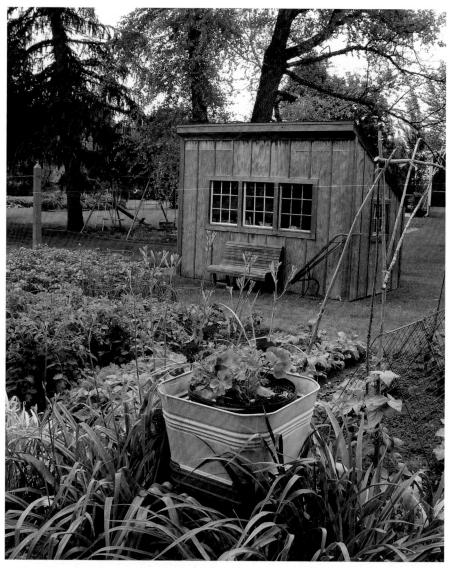

Interior Gardens

Unbroken interior grounds are a feature of the Amana villages. The shed at the Kellenbergers is in back of their vegetable garden. The frame at right supports pole beans. Gardening is a favorite activity in the Amanas with many families having vegetable and flower gardens. In some of the villages, vast rhubarb patches provide the stalks for *Piestengle,* a favorite wine made in the Amanas.

Above: Lilies grow by an old grinder at the Cooper Shop Museum in Middle Amana.
Below: The Kellenberger garden accents include a trellis and butterflies.

Hollyhocks in South Amana

Selected Bibliography

Albers, Marjorie K. *The Amana People and Their Furniture.* Ames, Iowa: Iowa State University Press, 1990.

Andelson, Jonathan G. "Communalism and Change in the Amana Society, 1855–1932." PhD diss., University of Michigan, 1974.

Bailey, Susan Strawn. "Knitting in the Amanas." *Piecework Magazine,* September/October 1997: 18–21.

Bendorf, Carl. "Friedrich Hahn: Amana Craftsman and Clockmaker." Unpublished paper. Amana Heritage Society, Amana, Iowa. n.d.

Bourret, Joan Liffring-Zug. *The Amanas: A Photographic Journey, 1959–1999.* Iowa City: Penfield Press, 2000.

Bourret, Joan Liffring-Zug, ed. *Life In Amana: Reporters' Views of the Communal Way, 1867–1935.* Iowa City, Iowa: Penfield Press, 1998.

Dow, James R., and Madeline Roemig. "Amana Folk Art and Craftsmanship." *Palimpsest* 58 (March/April 1977): 54–63.

Foerstner, Abigail. *Picturing Utopia: Bertha Shambaugh & the Amana Photographers.* Iowa City: University of Iowa Press, 2000.

Hinds, William Alfred. *American Communities.* New York: Corinth Books, 1961. (Reprint of 1878 edition).

Hoehnle, Peter. "Carl Flick and Grant Wood: A Regionalist Friendship in Amana." *Iowa Heritage Illustrated* 82 (Spring 2001): 2–19.

Hoehnle, Peter A. *The Amana People: The History of a Religious Community.* Iowa City, Iowa: Penfield Books, 2003.

Kellenberger, Jean, and Barbara Hoehnle. "Art and Pamphlet Series: Quilting, Basketmaking, Carpetweaving, Samplers and House Blessings, Utilitarian Woodwork, and Tinsmithing." Amana: Amana Arts Guild, 1982–.

Lankes, Frank James. *The Ebenezer Community of True Inspiration.* Buffalo, New York: Kiesling Publishing Company, 1949.

Liffring, Joan. "Iowa's Forgotten Lithographers." *The Iowan* (Winter 1964): 24–32, 51.

Liffring-Zug, Joan. "Old Amana in the Camera's Eye." *The Iowan* (Winter 1977): 22–29.

Liffring-Zug, Joan. *The Amanas Yesterday: A Religious Communal Society.* Iowa City: Penfield Press, 1975.

Nordhoff, Charles. *The Communistic Societies of the United States.* New York: Dover, 1966.

Ohrn, Steven. "Conserving Amana Folk Arts: A Community Remaining Faithful." *Palimpsest* 69 (Spring 1988):16–33.

Petersen, William J., ed. *Life in the Amana Colony.* The Palimpsest: Iowa City, Iowa: State Historical Society of Iowa, April 1971. Contains articles by Petersen, Albert Shaw, Richard T. Ely, Millard Milburn Rice, and Lulu MacClure on various aspects of Amana history.

Rettig, Lawrence L. *Amana Today: A History of the Amana Colonies from 1932 to Present.* Amana, Iowa: Amana Society, 1975.

Shambaugh, Bertha M.H. *Amana That Was and Amana That Is.* Iowa City, Iowa: The State Historical Society of Iowa 1932. The first part of this book is a reprint of *The Community of True Inspiration,* published in 1908, which was reprinted by Penfield Press, Iowa City, Iowa, in 1988 with the sponsorship of the Museum of Amana History and the State Historical Society.

Schanz, Joanna E. *Willow Basketry of the Amana Colonies.* Iowa City, Iowa: Penfield Press, 1986.

Selzer, Marie L. *Hobelspaen: A Collection.* Amana: Hobelspaen Publications, 1985.

Snyder, Ruth. "The Arts and Crafts of the Amana Society." M.A. Thesis, University of Iowa, 1949.

Watson, Clair Benjamin. "The Architecture and Minor Arts of the Amana Society." B.F.A. Thesis, University of Nebraska, 1935.

Weber, Philip E. *Kolonie-Deutsch.* Ames, Iowa: Iowa State University Press, 1993.

Worthen, Amy Namowitz. *Fruits and Flowers Carefully Drawn from Nature: 19th Century Lithographs from the Amana Colonies.* Des Moines: Des Moines Art Center, 2000.

Van Ravenswaay, Charles. *Drawn From Nature: The Botanical Art of Joseph Prestele and His Sons.* Washington, D.C.: Smithsonian Institution Press, 1984.

Yambura, Barbara Selzer, and Eunice W. Bodine. *A Change and a Parting: My Story of Amana.* Iowa City, Iowa: Penfield Press, 2001. (Revised ed. of book first published by Iowa State University Press, 1960).

Lily Lake Lily